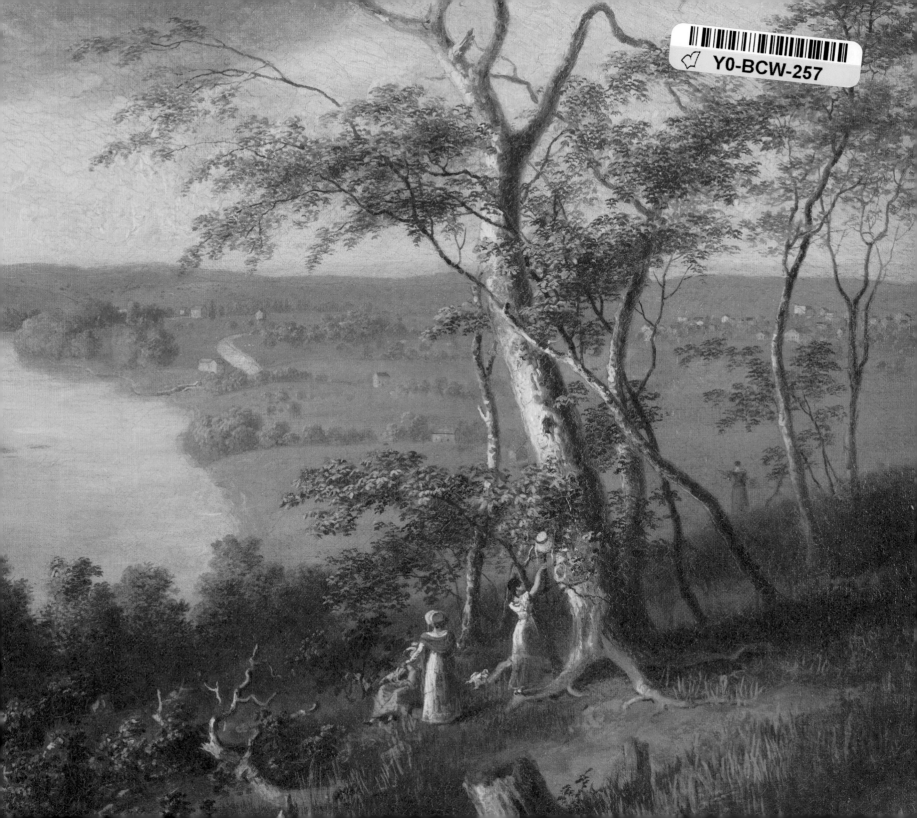

FROM THE Schuylkill TO THE Hudson

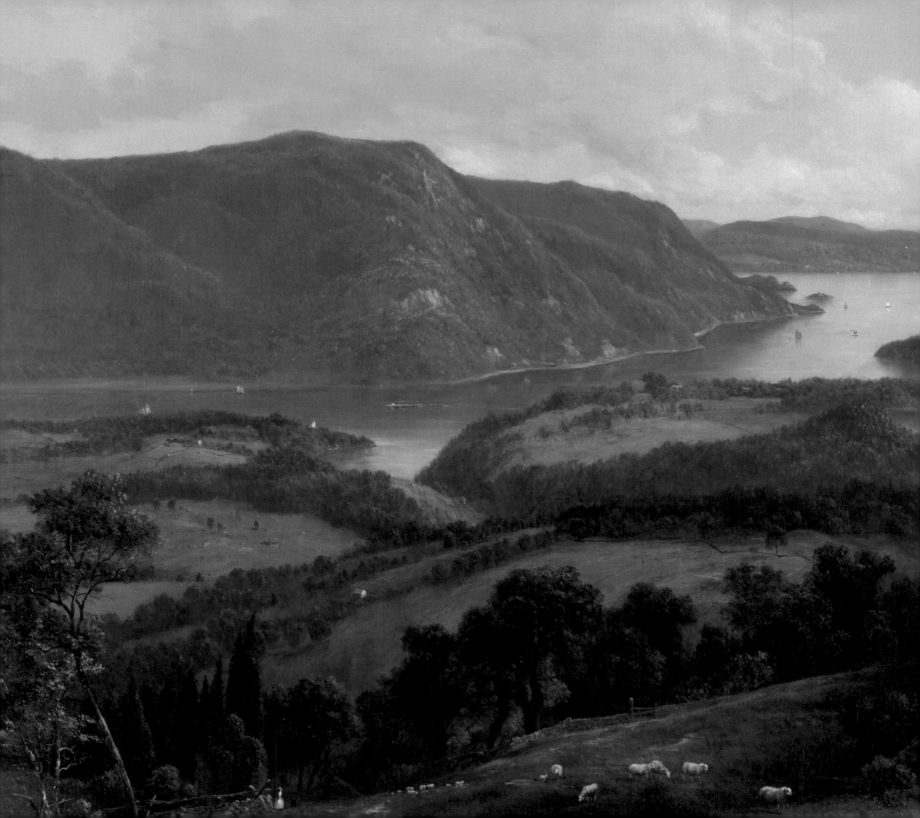

FROM
THE
Schuylkill
TO
THE
Hudson

LANDSCAPES OF THE
EARLY AMERICAN REPUBLIC

PENNSYLVANIA ACADEMY OF THE FINE ARTS

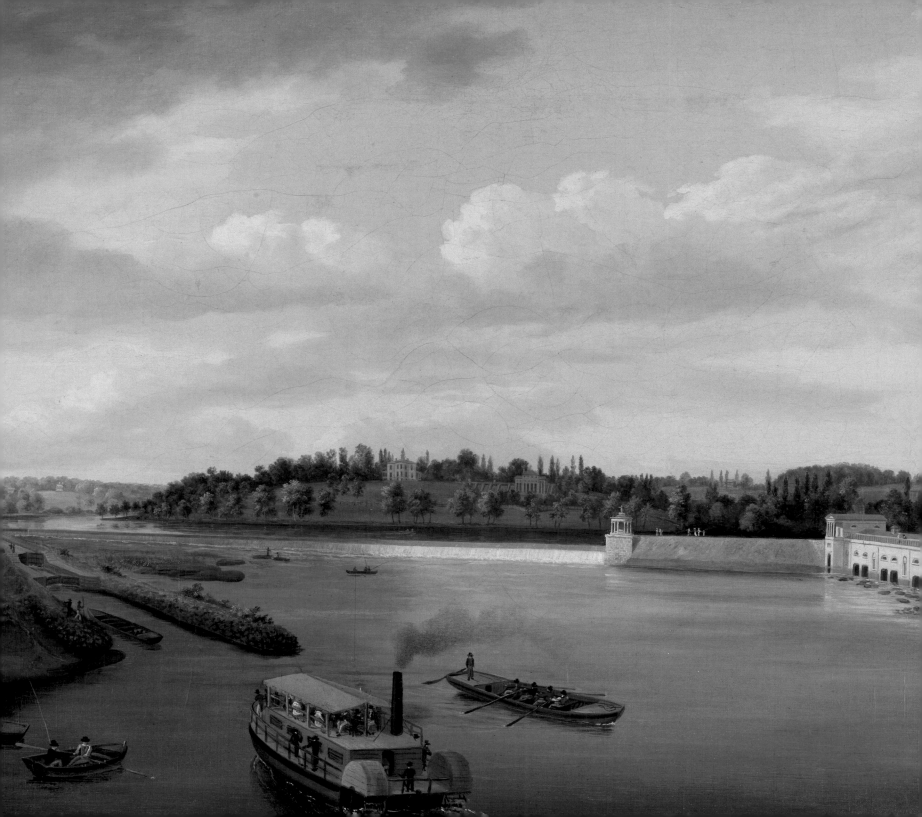

CONTENTS

Foreword

Dr. Anna O. Marley, curator of historical American art at the Pennsylvania Academy of the Fine Arts (PAFA), studied landscape representation in the British Atlantic World during her days as a graduate student at the University of Delaware. Anna was interested in how the artists of the Early Republican United States explored the landscape in art, and how their work then predated the Hudson River School of the 1820s, which has long been considered the "beginning" of a landscape tradition in this nation.

Anna has been a curator at PAFA since 2009, so it is particularly pleasing that we are featuring an exhibition that addresses the questions she has long asked of art history—and to which she has searched for answers in museum and private collections around the country.

All of us at PAFA are pleased to share the result of Anna's scholarly investigations, *From the Schuylkill to the Hudson: Landscapes of the Early American Republic,* a presentation that privileges our rich and expansive permanent collection. Many of her colleagues are especially excited to see the early depictions of the Schuylkill River by artists such as Thomas Doughty, Thomas Birch, and Joshua Shaw, who are part of the early history of PAFA, which was founded in 1805.

From the vantage point of a conventional history, this project seems almost radical in that it proposes a new lens through which to observe early American art—from the banks of the Schuylkill rather than the Hudson, claiming Philadelphia as the birthplace of a landscape tradition in America, rather than New York City. It shifts a long-held, long-believed narrative about the primacy of New York over Philadelphia, and it shows us that art history ought not to be written in ink, but in pencil, so that we can continue to discover, learn, adapt, and revise what artists tell us.

Our education team has been inspired by this project to explore the stories of these nineteenth-century American artists and the Pennsylvania landscape—both cultivated and wild. We are also thinking of the issues concerning land, nature, and water in the twenty-first century, through collaboration with the Fairmount Water Works and partners throughout the city of Philadelphia. We are excited to share the resultant programming with our audiences during the summer and fall, while this exhibition is on view in our Fisher Brooks Gallery.

The museum invited emerging scholar Ramey Mize to contribute to the project with an essay on the diverse symbolic meanings of American waterways in eighteenth- and nineteenth-century prints, and a companion show of works on paper featuring artists associated with the American Etching Revival and Impressionism whose work shows an ongoing interest in waterscapes. We congratulate Ramey on this exhibition,

Etch and Flow, on view in our Richard C. von Hess Foundation Works on Paper Gallery. The museum at PAFA regularly mentors young colleagues on the practice of being a curator: research, writing, and organizing exhibitions.

Anna and Ramey benefited from the hard work and boundless talent of PAFA's museum staff. I want to especially thank Judith M. Thomas, director of exhibitions, for her thorough and thoughtful editing and managing of the accompanying catalogue; Jennifer Johns, senior registrar, for assisting in the movement of artwork, loans, and shipping details; Monica Zimmerman, director of museum education, for working creatively on the educational opportunities for this project; and Jimmie Greeno, vice president of visitor experience and events management, for providing our visitors with a rich and pleasant—and perhaps provocative!—experience when looking at art at PAFA. It is always a team effort to realize an exhibition from idea to display.

While the majority of the artwork in this presentation is from our permanent collection, one of the richest collections of American art in public hands, we did benefit from several loans and I echo Anna's gratitude and thanks to our generous lenders on page 78. Additionally, I would like to thank my colleagues, Timothy Rub, George D. Widener Director and CEO at the Philadelphia Museum of Art; Carol B. Cadou, Charles F. Montgomery Director and CEO of Winterthur; and Charles Croce, executive director and CEO of the Philadelphia History Museum, for their generous institutional loans to the exhibition.

It is the support of our patrons that makes our exhibitions possible. An enormous debt of gratitude is owed to the Henry Luce Foundation, whose program director for American art, Dr. Theresa A. Carbone, offered gracious guidance; equally crucial aid has come from the Mr. and Mrs. Raymond J. Horowitz Foundation for the Arts, Inc., with the counsel of Max Berry; Bowman Properties, Ltd.; Brown Brothers Harriman & Co.; the Newington-Cropsey Foundation; the Foundation for Landscape Studies; Furthermore, a program of the J. M. Kaplan Fund; Julie and James Alexandre; Louisa C. Duemling; and Dorothy and Ken Woodcock. Special exhibitions like this benefit from the critical support of Jonathan L. Cohen and The Templeton Family. Many thanks from all of us at PAFA.

Additional thanks go to Linda Seyda and Robert Boris for their continued support of exhibitions presented in PAFA's Richard C. von Hess Foundation Works on Paper Gallery. The companion exhibition, *Etch and Flow*, has been made possible by their support, along with that of the IFPDA Foundation.

Lastly, I want to thank our audiences for visiting the galleries at PAFA to view *From the Schuylkill to the Hudson: Landscapes of the Early American Republic* and *Etch and Flow*. Let us engage in a conversation about the manner in which landscape painters can teach us about land stewardship, nature, community, and civic engagement.

BROOKE DAVIS ANDERSON
Edna S. Tuttleman Director of the Museum

ANNA O. MARLEY

The *Schuylkill River* School

Landscape Representation in Philadelphia from the American Revolution to the Centennial Exhibition

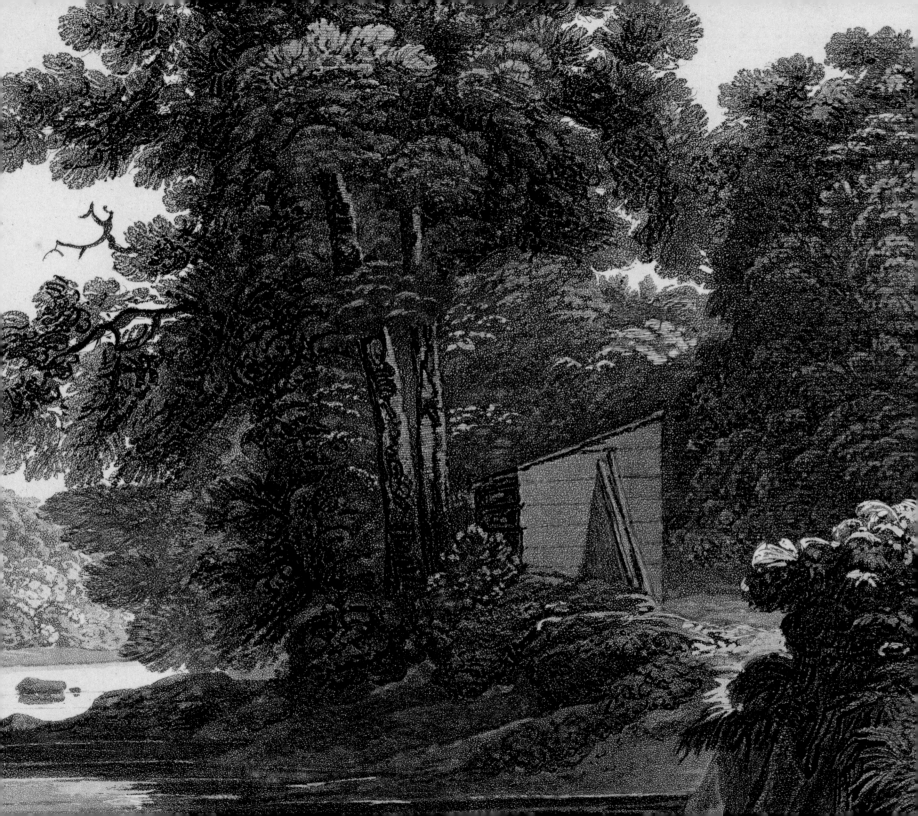

This essay posits the existence of a Schuylkill River School—not an organized society of artists, but rather a tradition of landscape art that developed around painters affiliated with the Pennsylvania Academy of the Fine Arts (PAFA) in the early American republic. The global image of a progressive, prosperous, industrial United States in the first quarter of the nineteenth century would come to be defined by this landscape school, which would go on to have a profound effect on Thomas Cole (1801–1848). Cole, who in the 1870s was posthumously crowned the "Father of the Hudson River School," had, as a young artist in the early 1820s, been immersed in the PAFA culture before first traveling up the Hudson in 1825.[1]

Centrally located between the banks of the mighty Delaware and the picturesque Schuylkill, the Early Republic's capital city of Philadelphia was defined and limited by those powerful borders—much as it is today (fig. 1).[2] Images of these rivers not only embodied the ideals of the new American nation-state, but also led to the creation of the Hudson River School, often erroneously identified today as the first American school of painting.[3]

Among the initial generation of professionally trained American artists to work in landscape in Philadelphia were brothers Charles Willson Peale (1741–1827) and James Peale (1749–1831), who were born into the British colonial empire on North American soil. Charles traveled to the metropolis of London, where he was trained by another former colonist, Benjamin West (1738–1820), at the Royal Academy. In both England and in Philadelphia, Charles and James were exposed to the British landscape genres of military topographic draftsmanship, conversation piece portraiture, overmantel decoration, and country house portraiture.[4] The influence of the British topographic impulse can be seen in Charles's *An East View of Gray's Ferry* (reproduced in the 1787 etching after Peale's original by James Trenchard [b. 1747]; plate 1) along the Schuylkill River. Gray's Ferry, and then later Gray's Bridge, was a strategic entry point to Philadelphia—for British troops during the Revolution, as well as for George Washington's triumphant reentries into Philadelphia in 1787 and 1789.

Primarily a portrait painter, Charles began experimenting with landscape in the 1770s in Philadelphia and Annapolis. In November 1772, he wrote to his patron, John Beale Bordley, "I hope it will be in my power to afford you some amusement with some drawings I have taken by my painters Quadrant—if you find any inclination to paint them, some are worthy of being painted, would do a Claud Lorain [*sic*] or a Salvator Rosa credit."[5] Despite his experimentation with his painter's quadrant and his evident skill as a draftsman, as seen in his

drawing *Lower falls of Schuylkill, 5 miles
from Philadelphia* (1770; see Mize, fig. 2,
p. 25), he was unable to complete major
landscape paintings as requested by his
patrons at this time. The works by the
Peale brothers that included landscapes
in the early years of the republic were
done in the style of the conversation piece,
exemplified in James's *The Artist and His*

Family (1795; plate 2), a group portrait
of his kin standing on the banks of the
gentle Schuylkill. It was only later in his
career that Charles began to paint pure
landscapes, when he was living at his farm
Belfield near Germantown, in what is now
Northwest Philadelphia (*Cabbage Patch,
The Gardens of Belfield, Pennsylvania*,
c. 1815–16; plate 3).

Before the explosion of landscape
painting in Philadelphia in the 1820s,
two British-born artists, William
Russell Birch (1755–1834) and Joshua
Shaw (c. 1777–1860), helped to create
the Schuylkill River School through
their respective serial print series, *The
Country Seats of the United States of
North America* (1808) and *Picturesque
Views of American Scenery* (1820).[6] Birch
conceived *Country Seats* from his own
rural residence, depicted in his minia-
ture painting *Springland: The Artist's
Residence* (after 1798; plate 4). Using the
tradition of British country house estate
portraiture and picturesque tourism as
a model, Birch's *Country Seats* was a
conscious attempt at the construction
of a new republican imagery through a
series of views of elite suburban homes
of the Early Republic. However, *Country
Seats*, unlike his earlier views of the city
of Philadelphia, was a financial failure,
perhaps because of his indebtedness to
British aristocratic modes of vision in a
nation very consciously attempting to
construct itself as a republic.

Shaw was a skilled painter trained in British landscape traditions, as seen in his *Landscape with Watermill* (c. 1818; plate 5). The printmaker John Hill (1770–1850) worked with Shaw's original artworks to etch scenes such as *View Near the Falls of Schuylkill* (1820; plate 6), which was included in *Picturesque Views*. The dramatic vertical orientation of this etching, with imposing rocks framing a view of the Schuylkill River, is surprisingly sublime in its composition, ascribing a dramatic power to the Falls of Schuylkill in the years before they were dammed as part of the Fairmount Water Works project.[7] While both of these British-born artists focused on picturesque and sublime imagery, the objective of the second generation of Philadelphia artists was to successfully capture the cultivated energy of the new republican landscapes of Philadelphia and, in particular, the Schuylkill River.

As early as the 1780s, Philadelphians were concerned about environmental degradation of this river, as well as the quality of the water available to the residents of the city. In a 1782 letter from Continental Congress delegate Francis Hopkinson to the *Pennsylvania Gazette*, the author lamented, "Look towards the banks of the Schuylkill. Where are now those verdant groves that used to grace the prospect?—Alas! nought now remain but lifeless stumps, that moulder in the summer and winter frost."[8] After the

American Revolution, periodic bouts of yellow fever ravaged the city and, in the 1790s, led to the development of a "Watering Committee" and ultimately the building of the facility seen in the engraving by Cornelius Tiebout (c. 1773–1832) after John James Barralet (c. 1747–1815), *View of the Water Works at Centre Square Philadelphia* (c. 1812; plate 7). Celebrated as a wonder of the modern city when it opened in 1802, the white temple of architect Benjamin Henry Latrobe's (1764–1820) waterworks appears dirty and corrupted, covered in billowing soot and surrounded by boisterous crowds, by the time that John Lewis Krimmel (1786–1821) painted *Fourth of July in Centre Square* (by 1812; plate 8).[9]

After the devastation wrought by the yellow fever and the subsequent move of the federal government to Washington, DC, in 1800, Philadelphia began to reinvent itself. As it morphed from a port and capital city to a major center of manufacturing, industry, and arts, the landscape representations from 1800 through the 1830s changed accordingly. PAFA academicians and board members were intimately connected with the growth of the city and the development of its waterworks. William Rush (1756–1833), one of PAFA's founding artist members, was the chairman of the Watering Committee's Building Committee in 1822, and his sculpture *Allegory of the Schuylkill River* (1809) formed the

centerpiece of the fountain at Centre Square, which can be seen in Krimmel's painting. He also sculpted *Allegory of the Schuylkill River in Its Improved State (The Schuylkill Chained)* and *Allegory of the Waterworks (The Schuylkill Freed)* in 1825, to be placed over the entranceways to the new millhouse at the waterworks, which was to replace the dilapidated Centre Square pump house.[10]

The second generation of Philadelphia landscape painters identified with the Schuylkill River School included artists Thomas Birch (1779–1851); Thomas Doughty (1793–1856; *Landscape with Curving River*, c. 1823; plate 9); Krimmel; and Jacob Eichholtz (1776–1842; *Mrs. Victor René Value, Her Daughter Victoria Matilda, and Her Stepson Jesse René*, c. 1830; plate 10). Thomas Sully (1783–1872), one of PAFA's leading instructors and the most popular Philadelphia portraitist of the 1820s and 1830s, noted in his *Journals* that he and Doughty and other artists, including his son-in-law John Neagle (1796–1875), would spend many pleasant hours sketching along the Schuylkill.[11] Thomas Birch and Doughty, who painted the river so often and whose work was replicated in mass-produced prints and ceramics (see Joseph Cone [active 1814–1830] after Doughty, *Fair Mount Water Works*, 1828; plate 11), would come to represent Philadelphia to a national and international audience.

FIG. 2 Thomas Doughty (1793–1856), *Land Storm*, 1822, oil on canvas, 23 × 31 in. Courtesy of the David and Laura Grey Collection

Later in the nineteenth century, the Schuylkill River was often depicted in a contained, scenic manner. This was not the case in the early nineteenth century, before the damming of the river and the creation of the Fairmount Water Works. Doughty's *Land Storm* (1822; fig. 2), like Hill's print of Shaw's *Falls of the Schuylkill*, published two years earlier, is a depiction of the Schuylkill River in the sublime mode. These works stand in marked contrast to later works by Doughty and by Thomas Birch, which show the Schuylkill controlled and contained, as do Rush's allegorical sculptures for the waterworks.[12] It was this image of the Schuylkill River that would come to symbolize the new American republic on a national and international stage.

The paintings of this group of artists created an explosion of popular images of the Schuylkill River that would travel around the world. In particular, scenes of the Fairmount Water Works in paintings shown at PAFA's annual exhibitions were, through the global distribution of prints such as Robert Campbell (active 1806–1831) after Birch, *View of the Dam and Waterworks at Fairmount,*

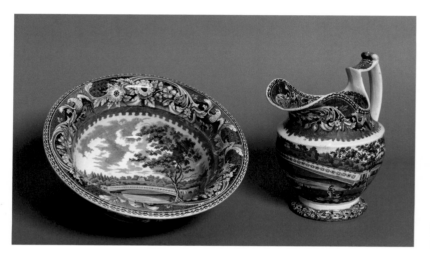

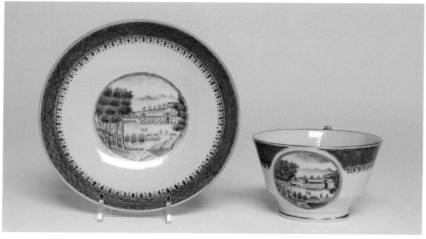

FIG. 3 Firm of Joseph Stubbs, *Pitcher and Basin*, 1825, glazed earthenware with transfer-printed decoration; pitcher: 9¾ × 9 × 7 in.; basin: 4½ × 12½ in. Private Collection

FIG. 4 Artist/maker unknown (Chinese, for export to the American market), *Cup and saucer showing the Philadelphia Waterworks*, c. 1820–30, hard-paste porcelain with cobalt underglaze decoration and gilt; cup: 2⅝ × 4⅝ × 3⅝ in.; saucer 1⅛ × 5½ in. Philadelphia Museum of Art, Gift of Mr. and Mrs. Brian Topping, 1994-18-2a and 2b

Philadelphia (1824; plate 12), transferred onto tableware produced in Bohemia, China, and Great Britain for elite and middle-class homes.[13] Often, images of the waterworks were used for vessels that held water—pitchers, basins, vases, and

teacups (fig. 3). One of the most beautiful examples of this is an object made in China for the American export market, *Cup and saucer showing the Philadelphia Waterworks* (c. 1820–30; fig. 4). It is no accident that this image of American salubriousness, of the purity and modernity of Philadelphia's water source, was depicted on a teacup—tea being the preferred drink of "teetotalers"—part and parcel of the projection of Philadelphia as a virtuous and uncontaminated city.[14] Thomas Birch's *Virtue and Vice, Sobriety and Drunkenness* (1815–30; fig. 5), painted after the completion of the waterworks, spells out clearly for the viewer the connection between contemporary temperance movements in Philadelphia and the creation of a

source of healthy water for the city. On the right side of the composition, Birch represents an elegantly dressed couple, a child who appears to be picking strawberries, and groups of picnickers enjoying the airy breezes and refined architecture of the waterworks and river. A "temperance tree" divides the virtuous side from the vice-filled one, where on the left side of the work the desiccated tree hovers above a drunken man and his distraught wife and weeping child. In the background, a group of men sit in front of a tavern. Like Birch's oils on canvas, this watercolor was reproduced for many purposes, including an 1836 German-language temperance almanac that was titled *Der Massigkeits-Baum* (*The Temperance Tree*).[15]

The popularity of these Schuylkill River artists, in particular Doughty and Thomas Birch, was to have a profound influence on a young British immigrant to the United States, Thomas Cole. In the fall of 1823, Cole began studying from the casts and paintings collections at PAFA, and exhibited his first painting professionally at PAFA's thirteenth annual exhibition in May 1824.[16] Cole later told the early-American art historian William Dunlap that during this time "his heart sunk as he felt his deficiencies in art when standing before the landscapes of Birch."[17] One of the paintings that might have made Cole's heart sink is Birch's *Fairmount Water Works* (1821; plate 13), which was shown in that 1824 PAFA exhibition. Remarkably executed in minute detail, this painting shows picturesque beauty and industry in harmony along the Schuylkill River, including details of the new waterworks, Schuylkill River canal, the first steamship to travel up the waterway, and the beauty of Lemon Hill Mansion perched on the banks above the river. By the 1840s, Doughty and Cole were often reviewed together as peers. In 1848, the *Knickerbocker Magazine* wrote of their work, exhibited together in New York City, "Doughty's pictures and Cole's pictures should be placed apart from the rest. We all admit them to be our masters."[18]

However, even though the Schuylkill River School gave birth to the better-known Hudson River School, Philadelphia painters, along with printmakers and ceramicists, were not immune to the influence of the New York school of painters after the 1830s, with Cole by that time foremost among them. Like Birch and Doughty before him, Cole's paintings were copied as prints (Fenner, Sears & Co. after Cole, [A Distant View of the Falls of Niagara], 1831; plate 14) and then transposed onto transferware in Great Britain for the American and domestic market (William Adams and Sons Factory after Cole, *The Falls of Niagara, U.S.*, 1834–50;

FIG. 5 Thomas Birch (1779–1851), *Virtue and Vice, Sobriety and Drunkenness*, 1815–30, ink, wash, paper, 10 × 14⅝ in. Courtesy of the Winterthur Museum, Museum purchase, 1967.0131

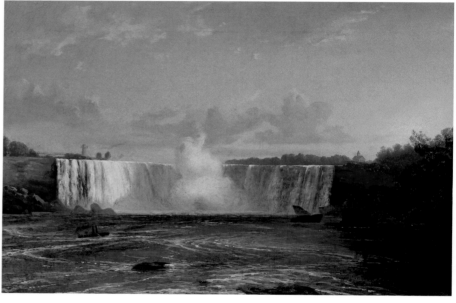

FIG. 6 William Adams and Sons Factory (Staffordshire, England) after Thomas Cole (1801–1848), *The Falls of Niagara, U.S.*, 1834–50, earthenware and lead glaze platter, 1¾ × 20 in. Courtesy of the Winterthur Museum, Bequest of Henry Francis du Pont, 1966.0839

FIG. 7 Thomas Birch (1779–1851), *Niagara Falls*, 1845, oil on canvas, 14 × 20 in. Private Collection

fig. 6). The dominance of the Hudson River School was tied to New York's expanding fortune and growing identity as the Empire State; with the completion of the Erie Canal in 1825 and its expansion in 1834, the port of New York City eclipsed every other US city with its ready access to both the Atlantic Ocean and, via the Hudson and Erie Canals, the Great Lakes. Niagara Falls, near the terminus of the canal at Lake Erie, enjoyed ever-increasing popularity, and eclipsed the Fairmount Water Works as a symbol of the prosperity and power of the United States. Even Philadelphia painters like Thomas Birch were to make pilgrimages up the canal to paint the sublime, and newly accessible, *Niagara Falls* (1845; fig. 7).

In the 1840s, as Cole made popular the trend of American landscape painters traveling abroad, with paintings like *View of Sicily* (c. 1842–45; plate 15), some Philadelphia painters remained uninfluenced by the Hudson River School's more romantic mode of landscape painting and worked in the tradition of country house portraiture. William Thompson Russell Smith (1812–1896) was perhaps the most prolific landscape painter working in mid-nineteenth-century Philadelphia (*Chew House, Germantown*, 1843; plate 16). He worked alongside artists, many of whose names

are unknown to us today, to capture not only private country house views, but also more public spaces. These included sites of recreation and picturesque tourism, such as Laurel Hill Cemetery (unidentified artist, *Laurel Hill Cemetery Gate, Philadelphia*, c. 1840; plate 17), founded in 1836, which was also often depicted by young women sketching and copying in watercolor and pencil (unidentified artist, *Laurel Hill Cemetery*, c. 1840s; fig. 8).[19]

From the 1850s through the mid-1870s, the second generation of Hudson River School painters dominated the exhibition of landscapes in both Philadelphia and New York. While today we often associate these artists with views of the Hudson River Valley, they were never bound exclusively to that area, though many had studios in New York City and some, like Cole, Frederic Edwin Church (1826–1900), and Jasper Francis Cropsey (1823–1900), had homes along the Hudson River. Artists who followed in Cole's footsteps by traveling to Italy included Cropsey (*Landscape with Figures Near Rome*, 1847; plate 18) and Sanford Robinson Gifford (1823–1880; *Saint Peter's from Pincian Hill*, 1865; plate 19). Other Hudson River School artists would stay closer to home, such as Robert Seldon Duncanson (1821–1872); John Frederick Kensett (1816–1872; *At Newport, Rhode Island*, c. 1855; plate 20); Asher Brown Durand (1796–1886; *Landscape: Creek and Rocks*, 1850s; plate 21); David Johnson (1827–1908; *The Hudson River from Fort Montgomery*, 1870; plate 22); Albert Bierstadt (1830–1902; *Niagara*, 1869; plate 23); George Inness (1825–1894); and William Frederick de Haas (1830–1880; *Biddeford Beach, Coast of Maine*, 1875; plate 24). Still others would travel further afield to South America—Martin Johnson Heade (1819–1904; *Sunset Harbor at Rio*, 1864; plate 25) and Church (*Valley of Santa Ysabel, New Granada*, 1875; plate 26), who also inspired William Forrest (1805–1889; *The Heart of the*

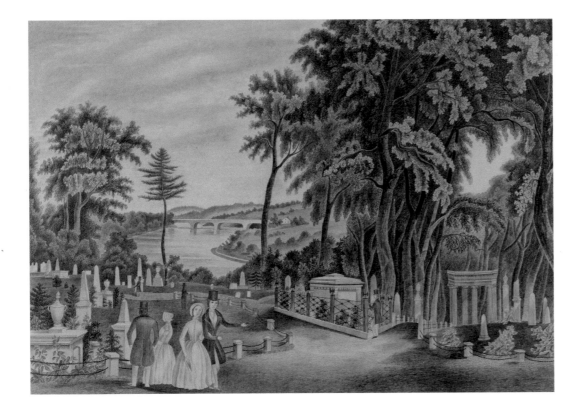

FIG. 8 Unidentified artist, *Laurel Hill Cemetery*, c. 1840s, graphite on paper, 11½ × 15 in. Private Collection

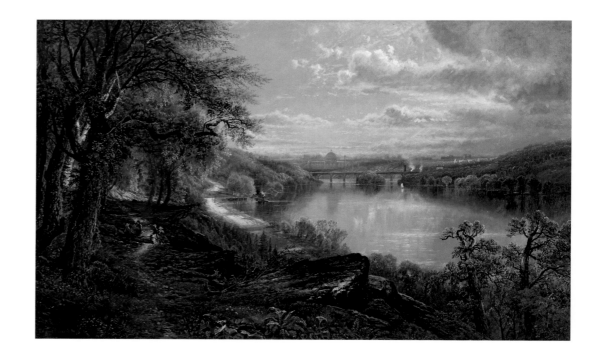

Andes, 1862; plate 27)—and to the mountainous regions of the United States (Cropsey, *Mount Washington from Lake Sebago, Maine*, 1867; plate 28). The work of these artists was also widely distributed through print media. James Smillie (1807–1885) was one of the most prolific and successful engravers of Hudson River School artists, and PAFA's collection includes prints after Cole, Doughty, Durand, Kensett (such as Smillie's print of his *Mount Washington*, 1851; plate 29), and more.[20]

The fourth generation of Philadelphia landscape painters—William Trost Richards (1833–1905), Thomas Moran (1837–1926), and Edmund Darch Lewis (1835–1910)—were working in a style that by the 1870s had become specifically associated with the Hudson River School. Moran's *Two Women in the Woods* (1870; plate 30), showing a walk along Philadelphia's Wissahickon Creek on what is now called Forbidden Drive, was painted one year before the artist began the iconic paintings of Yellowstone for which he is best known. At the same time, Augustus Köllner (1813–1906) was creating popular mass-produced

chromolithographic prints of the creek (*In Wissahickon Valley*, 1876; plate 31) that reached a much larger audience than the paintings of Moran and Richards (*Paschall Homestead at Gibson's Point, Philadelphia*, 1857; plate 32).

Perhaps the definitive Hudson River School painting of the Schuylkill, and an appropriate ending to our voyage from the Schuylkill to the Hudson and back again, is Edmund Darch Lewis's *View of the Schuylkill River with Memorial Hall in the Background* (1876; fig. 9), which commemorated the Centennial Exhibition held in Philadelphia's Fairmount Park in

1876. The Exhibition celebrated one hundred years of nationhood, and brought the world to the city. In Lewis's very local view of Philadelphia's own Schuylkill, one can see the dominance of the Hudson River School at its apex; a style not only used to capture the Hudson, as in Johnson's majestic vision of that river, but a style equally applied to Church's atmospheric visions of South America, or Bierstadt's sublime paintings of Niagara on the border with British Canada. One hundred years after the American Revolution, the transition from the Schuylkill to the Hudson and beyond was made complete.

NOTES

1. For a selection of influential works on the history of the Hudson River School, and specifically Thomas Cole, see Barbara Novak, *Nature and Culture: American Landscape and Painting, 1825–1875* (Oxford: Oxford University Press, 1980); William H. Truettner and Allan Wallach, *Thomas Cole: Landscape into History* (New Haven: Yale University Press, 1994); Angela Miller, *The Empire of the Eye: Landscape Representation and American Cultural Politics, 1825–1875* (Ithaca: Cornell University Press, 1996); Andrew Wilton and Tim Barringer, *American Sublime: Landscape Painting in the United States, 1820–1880* (London: Tate Publishing, 2002); Linda S. Ferber, *The Hudson River School: Nature and the American Vision* (New York: Skira Rizzoli for the New-York Historical Society, 2009); Tim Barringer, Gillian Forrester, Sophie Lynford, Jennifer Raab, and Nicholas Robbins, *Picturesque and Sublime: Thomas Cole's Trans-Atlantic Inheritance* (New Haven: Thomas Cole National Historic Site in association with Yale University Press, 2018); Elizabeth Mankin Kornhauser and Tim Barringer, *Thomas Cole's Journey: Atlantic Crossings* (New York: The Metropolitan Museum of Art and Yale University Press, 2018).

2. For a recent masterful study of Philadelphia and its rivers, see Elizabeth Milroy, *The Grid and the River: Philadelphia's Green Places, 1682–1876* (University Park: The Pennsylvania State University Press, 2016).

3. The idea of the Hudson River School not only negates the importance of landscape painters working in Philadelphia before 1825, but it likewise obscures Thomas Cole's deep artistic roots in an imperial British Atlantic world and denies the existence of indigenous and First Nations' representations of the landscape in North America.

4. For more on British topographic landscapes in the Americas, see John E. Crowley, *Imperial Landscapes: Britain's Global Visual Culture, 1745–1820* (New Haven: Yale University Press for the Paul Mellon Centre for Studies in British Art, 2011), and Bruce Robertson "Venit, Vidit, Depinxit: The Military Artist in America," in Edward J. Nygren, *Views and Visions: American Landscape before 1830* (Washington, DC: Corcoran Gallery of Art, 1986), pp. 83–104. For an excellent recent history of the conversation piece, see Kate Retford, *The Conversation Piece: Making Modern Art in 18th-Century Britain* (New Haven: Yale University Press for the Paul Mellon Centre for Studies in British Art, 2017). For a study into the importance of overmantel landscapes, see this author's *Rooms with a View: Landscape Representation in the Early National and Late Colonial Domestic Interior*, University of Delaware Dissertation, 2009. One of the best sourcebooks on British country house portraiture is contained in the collection of papers presented in *The Fashioning and Functioning of the British Country House* (Center for Advanced Study in the Visual Arts, National Gallery of Art, Washington, DC, 1986).

5. Charles Willson Peale to John Beale Bordley, November 1772. Lillian B. Miller, ed., *The Selected Papers of Charles Willson Peale and his Family: Volume I, Charles Willson Peale: Artist in Revolutionary America, 1735–1791*, 5 vols. (New Haven: Yale University Press for the National Portrait Gallery, 1983), I: p. 127.

6. For an in-depth analysis of Birch's *Country Seats*, see Emily T. Cooperman "'The Only Work of the Kind': The Country Seats of the United States," in Cooperman and Lea Carson Sherk, *William Birch: Picturing the American Scene* (Philadelphia: University of Pennsylvania Press, 2011), pp. 129–59.

7. For a definition of "the sublime," see Ramey Mize's essay in this volume, pp. 21–27. Her essay focuses in depth on the landscape works on paper held in the PAFA collection, including some of the works cited in this essay.

8. Cited in Laura Turner Igoe, "'Appropriate in a Sylvan State': William Rush's Self-Portrait and Environmental Transformation," in *American Art* (Spring 2014), p. 96.

9. For an excellent discussion of the visual representation of the Centre Square Waterworks in Early Republican Philadelphia, see Laura Turner Igoe, "'Covert of Danger and Blood': The Incorporation of the Centre Square Waterworks," in *The Opulent City and the Sylvan State: Art and Environmental Embodiment in Early National Philadelphia*, Temple University Dissertation, 2014, pp. 94–159.

10. Jane Mork Gibson and Robert Wolterstorff, "The Fairmount Waterworks," *Philadelphia Museum of Art Bulletin*, Vol. 84, No. 360/361 (Summer 1988), p. 27.

11. *Journal of Thomas Sully*, August 14, 1826, p. 43, Smithsonian Archives of American Art.

12. Unlike Shaw and William Birch, Doughty and Thomas Birch were trained in the United States, Birch by his father and Doughty by copying European paintings owned by wealthy US collectors like Robert Gilmor Jr.

of Baltimore. See Frank H. Goodyear Jr., *Thomas Doughty, 1793–1856: An American Pioneer in Landscape Painting* (Philadelphia: Pennsylvania Academy of the Fine Arts, 1973), p. 13.

13. For more on the relationship between the Schuylkill River and the temperance movement in the 1830s, see Milroy, "The Fairmount Water Works: Picturing Civic Virtue," in *The Grid and the River*, pp. 181–208.

14. "Teetotal" and "teetotaler" first appeared with their current meanings in 1834, eight years after the formation of the American Temperance Society. www.merriam-webster.com/dictionary/teetotaler.

15. Georg W. Menz & Son (publisher) *Pennsylvania Temperance Calendar*, 1836. Winterthur Museum, STH004.

16. Shannon Vittoria, "Chronology," in Kornhauser and Barringer, *Thomas Cole's Journey*, p. 247.

17. William Dunlap quotation cited in William Lavine Coleman, "Something of an Architect: Thomas Cole and the Country House Ideal," University of California, Berkeley, Dissertation, 2015, p. 32.

18. Goodyear Jr., *Thomas Doughty, 1793–1856*, p. 11.

19. For more on images of Laurel Hill Cemetery, see Aaron Vickers Wunsch, "Parceling the Picturesque: 'Rural' Cemeteries and Urban Context in Nineteenth-Century Philadelphia," University of California, Berkeley, Dissertation, 2009.

20. For further discussion of Smillie's prints, see Mize, p. 26.

RAMEY MIZE

Landscape's Expressive Eye

The Shifting Symbolism
of Waterways in
Early American
Print Culture

Water, in its various manifestations, serene or storm-tossed, trickling or cascading, constitutes an integral element of eighteenth- and nineteenth-century landscape representation in the United States.[1] In 1810, Joseph Hopkinson (1770–1842), the president of the Pennsylvania Academy of the Fine Arts (PAFA), stressed the pivotal potential of river subjects in his first "Annual Discourse" at the institution: "Do not our vast rivers, vast beyond the conception of the European, rolling over immeasurable space . . . afford the most sublime and beautiful objects for the pencil of the landscape?"[2] Twenty-five years later, Thomas Cole (1801–1848), the celebrated landscape painter of the Hudson River School, expressed appreciation for waterways in his "Essay on American Scenery." Without water, Cole averred, "every landscape is defective. Like the eye in the human countenance, it is a most expressive feature: in the unrippled lake, which mirrors all surrounding objects, we have the expression of tranquility and peace—in the rapid stream, the headlong cataract, that of turbulence and impetuosity."[3]

This essay will explore the host of diverse symbolic meanings embodied in the depictions of American waterways in PAFA's rich collection of works on paper, examining the various ways in which artists adapted bodies of water—notably within and around the Schuylkill, Niagara, and Hudson Rivers—as powerful vehicles for aesthetic, national, and spiritual ideals.

Niagara Falls was among the earliest North American water motifs in both art and literature, later becoming the premier tourist destination of the nineteenth century upon the construction of the Erie Canal in 1825. PAFA's *Cataract of Niagara* (1774; plate 33), a print by William Byrne (1743–1805), was made after the second-known drawing of Niagara,[4] which had been completed by Lieutenant William Pierie (active late 1700s) while stationed at Fort Niagara in 1768.[5] Richard Wilson (1714–1782), one of Britain's foremost landscape painters, referred to Pierie's drawing for his large-scale painting *The Falls of Niagara*, completed and exhibited at the Royal Academy in 1774. Byrne completed his engraving soon thereafter; in it, one can discern several compositional devices intended to enhance the impression of the cataract's vast grandeur, such as the sweeping horizon line and the exaggerated scope of the falls, especially in comparison to the diminutive scale of the human figures in the foreground.[6]

The late eighteenth-century aesthetic category of "the sublime," as defined by the Irish statesman and philosopher Edmund Burke (1729–1797) in 1757, involved sensations of suspense, terror, and awe, generally aroused in the face of volatile natural phenomena.[7] Pierie's elevated view of Niagara Falls exemplifies

the dread-inducing conditions of Burke's Romantic-Gothic sublime; indeed, the vigorous commingling of mist and spray with the thick, almost ominous, clouds in the print is palpably suggestive of the cataract's perilous energy.[8]

By the 1830s, however, popular understandings of the sublime shifted; rather than inspiring a combination of fear and elation, sublimity now connoted spiritual transcendence and emotional tranquility.[9] In landscape views, the glassy surface of mirror-like lakes signaled this meditative attitude to great effect, as reflected in Robert Hinshelwood's (1812–after 1875) engravings [Lake George] (1870; plate 34), after a painting by John William Casilear (1811–1893), and *Echo Lake, New Hampshire* (c. 1850–60; plate 35), after a painting by Jasper Francis Cropsey (1823–1900). The sublime's new association with repose was true for Niagara Falls as well. Following Nathaniel Hawthorne's (1804–1864) visit in 1834, for example, the writer claimed that the tumult "soothes while it awes the mind."[10] Cole described Niagara as both sublime and beautiful, the two "bound together in an indissoluble chain."[11] The engraving by Fenner, Sears & Co. (1831; plate 14) after his 1830 canvas [A Distant View of the Falls of Niagara], encapsulates this transcendent quietude. Unlike the visceral immediacy of the Byrne-Pierie print, the falls are portrayed here at a distance, their turmoil softened by

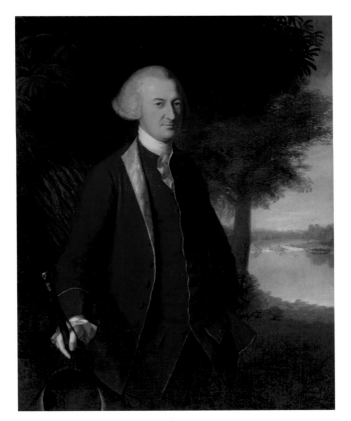

FIG. 1 Charles Willson Peale (1741–1827), *John Dickinson*, 1770, oil on canvas, 49 × 39¼ in. Courtesy of the Philadelphia History Museum at the Atwater Kent, The Historical Society of Pennsylvania Collection, HSP.1926.1

the surrounding landscape and the running river below.[12] Niagara is no longer an overwhelming force, but rather a site for nostalgic contemplation. Indeed, Cole's view is an imaginative and wistful one, for the artist pointedly omitted the mills and hotels which by then encircled the cataract.

Around the same time that British military artists were disseminating views of Niagara Falls to European audiences, Charles Willson Peale (1741–1827) was inspired by a smaller but similarly meaningful cascade along Philadelphia's Schuylkill River for his allegorical portrait *John Dickinson* (1770; fig. 1). In

this composition, the waterway conveys a political message, one that goes far beyond the more typical eighteenth-century trope of landscape as generic, picturesque backdrop.[13] To be sure, the insertion of the recognizable Philadelphia scenery is critical to the message of the statesman's portrait, which signified colonial protest and resistance to British rule. Dickinson's role as the anonymous author of *Letters from a Farmer in Pennsylvania* (1767–68), a series of essays which denounced the Townshend Duties, was ultimately revealed with great fanfare at a ceremony held by the Fort St. David's fishing company, located in close proximity to the falls.[14] Peale's detailed preparatory sketch, *Lower falls of Schuylkill, 5 miles from Philadelphia* (1770; fig. 2), is further evidence of his investment in the cataract's site-specific distinction. Together, the painting and drawing presage landscape's trajectory from a secondary, contextual tool in portraiture to a central subject in its own right in the nineteenth century.

As Peale's portrait suggests, Philadelphians regarded the Schuylkill Falls as a treacherous, potentially life-threatening obstacle, and the extent of this wariness is important for understanding the full significance of the artist's drawing *An East View of Gray's Ferry* (reproduced as a print by James Trenchard [b. 1747], 1787; plate 1).[15] Here, Peale represents Gray's Ferry, a floating

bridge originally built by the British in 1777. By the time Peale had rendered it, ten years later, the bridge also led to a pleasure garden located on the west bank of the Schuylkill, a popular retreat that was also a frequent setting for Federalist events.[16] This drawing provided the design for an engraving published in *The Columbian Magazine*, the first American periodical to interpret original views of native scenery as cultural emblems.[17] Pathways feature prominently in this early illustrated journal, visualizing and exhorting continental travel, and implicitly, the control of all terrain traversed.[18] In this vein, Peale depicts the floating bridge from an intimate, ground-level perspective, almost as if to invite the viewer to not only cross, but also lay claim to both the river and the United States as a whole. Here, the Schuylkill is no longer pictured as the precarious entity that once formed the backdrop to Peale's revolutionary Dickinson portrait—by 1787, it is a navigable, scenic stream, a fitting analog for republican virtue.[19]

Engraved views in *The Country Seats of the United States of North America* by William Russell Birch (1755–1834), the second set of reproductive landscapes ever published in the United States, focused also on the Schuylkill and its stately suburban retreats.[20] *Mendenhall Ferry, Schuylkill, Pennsylvania* (1808; plate 36), like Peale's and Trenchard's *An East View of Gray's Ferry*, demonstrates

an appreciation for the incorporation of "internal improvements" throughout the river's lush environs. In the Early Republic, nature and culture were employed as vital, harmonious parts of the nation-building project, with technology and infrastructure considered progressive, rather than compromising, additions to landscape.[21] Birch certainly valued the metaphorical potential of such contrast, often pairing representations of what he called "wild, unregulated nature" with the planned grandeur of domesticated plots.[22] In the foreground of *Solitude in Pennsylva. belonging to Mr. Penn* (1808; plate 37), for instance, the rugged rocks and foliage both frame and enhance the pristine lawn and estate beyond. Twenty years later, Joseph Cone (active 1814–1830) builds upon the symbolic redolence of these juxtapositions in the print *Fair Mount Water Works* (1828; plate 11).[23] Here, the artist has balanced a gnarled stump on the same central plane as the

FIG. 2 Charles Willson Peale (1741–1827), *Lower falls of Schuylkill, 5 miles from Philadelphia*, 1770, pen and brown ink with brown and black washes over graphite on laid paper, 7¾ × 12¼ in. Philadelphia Museum of Art, Gift of the McNeil Americana Collection, 2009-18-1

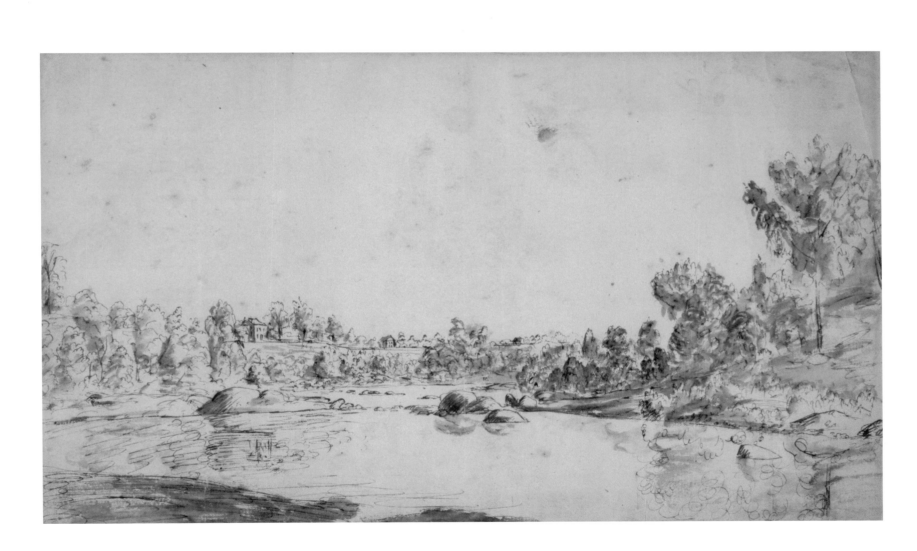

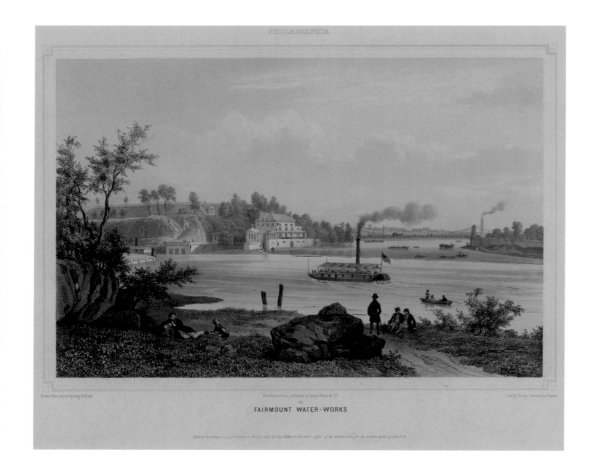

FAIRMOUNT WATER-WORKS

FIG. 3 Isidore Laurent Deroy (1797–1886) after Augustus Köllner (1813–1906), *Philadelphia—Fairmount Water-Works*, c. 1848, lithograph, 12½ × 9½ in. Private Collection

tidy dam at far left, with the waterworks and several leisure seekers tucked neatly in between.[24] Through this evocative combination, Cone alludes to the harnessing of natural resources in the construction of public works, positing the river as a fruitful force in the service of both industry and art.[25] The lithograph *Philadelphia—Fairmount Water-Works* (c. 1848; fig. 3) by Isidore Laurent Deroy (1797–1886) after Augustus Köllner (1813–1906) enacts an even more integrative view, highlighting the Schuylkill's role as an essential artery between city and country, production and recreation, travel and repose.[26]

Connectivity counts among water's most unique properties; rivers wend their way through urban and rural zones, linking together disparate people and places along their fluid, life-giving thoroughfares.[27] Cole elaborated beautifully on the metaphorical dimensions of the river in *The Voyage of Life* (1839–40). This series, comprising four large paintings, *Childhood*, *Youth*, *Manhood*, and *Old Age*, allegorizes the path of life as a river voyage.[28] James Smillie's (1807–1885) engravings after each canvas (c. 1850–60s; plates 42–45) demonstrate the widespread popular appeal of Cole's visual narrative.[29] These works, the last major undertakings of Cole's artistic career, powerfully recall the artist's earlier rumination on the expressive impact of water in landscape—a fact reinforced by the subject's compelling diversity in PAFA's print holdings.

NOTES

1. For more on the distinctive role of water in early American landscape painting, see Barbara Novak, *Nature and Culture: American Landscape and Painting, 1825–1875* (Oxford: Oxford University Press, 2007), and John Wilmerding, *The Waters of America: Nineteenth-Century American Paintings of Rivers, Streams, Lakes, and Waterfalls* (New Orleans: New Orleans Museum of Art and the Historic New Orleans Collection, 1984).

2. Joseph Hopkinson, "Annual Discourse," *Port Folio* 4, No. 6 (December 1810): Supplement, p. 33.

3. Thomas Cole, "Essay on American Scenery (1835)," in *The Native Landscape Reader*, ed. Robert E. Grese (Amherst: University of Massachusetts Press, 2011), p. 31.

4. Jeremy Adamson, *Niagara: Two Centuries of Changing Attitudes, 1697–1901* (Washington, DC: Corcoran Gallery of Art, 1985), p. 22. The first artist to make an on-the-spot sketch of Niagara Falls was Lieutenant Thomas Davies (c. 1737–1812) during a tour of the Lake Ontario shoreline in 1760–61.

5. Throughout the second half of the eighteenth century, British officers provided many of the earliest landscape views of North America; the engravings made after their firsthand sketches significantly influenced not only the European perception of America, but also the American landscape tradition. For a detailed treatment of this topic, see Bruce Robertson, "Venit, Vidit, Depinxit: The Military Artist in America," in Edward J. Nygren with Bruce Robertson, *Views and Visions: American Landscape Before 1830* (Washington, DC: Corcoran Gallery of Art, 1986), pp. 83–103.

6. Adamson, *Niagara*, pp. 22–23.

7. Burke delineated his definitions of "the sublime" versus "the beautiful" in his influential *Philosophical Enquiry into the Origins of Our Ideas of the Sublime and the Beautiful*, first published in 1757.

8. Novak, *Nature and Culture*, p. 30.

9. Adamson, p. 42.

10. Nathaniel Hawthorne, "My Visit to Niagara," in *The Complete Works of Nathaniel Hawthorne*, 22 vols. (Boston: Houghton and Mifflin, 1900), 17: p. 251.

11. Cole, "Essay on American Scenery (1835)," in *The Native Landscape Reader*, p. 33.

12. Adamson, pp. 49–50; Linda L. Revie, *The Niagara Companion: Explorers, Artists and Writers of the Falls, from Discovery through the Twentieth Century* (Ontario: Wilfrid Laurier University Press, 2003), p. 47.

13. Karol Ann Peard Lawson, "Charles Willson Peale's 'John Dickinson': An American Landscape as Political Allegory," *Proceedings of the American Philosophical Society* 136, No. 4 (December 1992): p. 458.

14. Ibid., pp. 475–77. Duties imposed under the Townshend Acts, named for British Chancellor of the Exchequer Charles Townshend, placed an indirect tax on glass, lead, paints, paper, and tea, goods that were not produced within the colonies and had to be imported from Britain. www.britannica.com/event/Townshend-Acts.

15. A 1793 notice in *The New York Magazine, or Literary Repository* concluded, "Of all the obstructions by which the navigations of the Schuylkill is interrupted, that of the Lower Falls . . . is by far the most formidable They have now and then proved fatal to persons attempting to pass them, the waters being low." Quoted in Lawson, "Charles Willson Peale's 'John Dickinson,'" p. 478.

16. The ferry, grounds, and accompanying tavern had been managed by the Gray family since the 1720s; George Gray Jr. and Robert Gray, the sons of George Gray Sr., marched in the Federal Procession in 1788. Elizabeth Milroy, *The Grid and the River: Philadelphia's Green Places, 1682–1876* (University Park: The Pennsylvania State University Press, 2016), p. 103.

17. Karol Ann Peard Lawson, "An Inexhaustible Abundance: The National Landscape Depicted in American Magazines, 1780–1820," *Journal of the Early Republic* 12, No. 3 (Fall 1992): p. 305.

18. Ibid., p. 311.

19. Milroy, *The Grid and the River*, p. 111.

20. The first set of engraved landscapes to be published in the country was also issued by William Russell Birch in 1800, titled *City of Philadelphia in the State of Pennsylvania, North America, as It Appeared in the Year 1800*. See Emily T. Cooperman, ed., *William Russell Birch, The Country Seats of the United States* (Philadelphia: University of Pennsylvania Press, 2009), p. 1.

21. Milroy, p. 193.

22. Quoted ibid., p. 134; for further discussion of Birch's interest in the more sublime aspects of American scenery, see Emily T. Cooperman and Lea Carson Sherk, *William Birch: Picturing the American Scene* (Philadelphia: University of Pennsylvania Press, 2011).

23. Cone's print is based on a painting by the artist Thomas Doughty, entitled *View of the Fairmount Waterworks*, c. 1824–26. For an overview of Doughty's artistic output, see Frank H. Goodyear Jr., *Thomas Doughty (1793–1865): An American Pioneer in Landscape Painting* (Philadelphia: Pennsylvania Academy of the Fine Arts, 1973).

24. It is difficult to overstate the extent of the attraction held by the Fairmount Water Works for visitors and Philadelphians alike. For more on the waterworks' unique assembly of nature and technology, engineering and tourism, see Jane Mork Gibson's article "The Fairmount Waterworks," in *Philadelphia Museum of Art Bulletin* 84, No. 360/361 (Summer 1988): pp. 1–46, as well as Chapter 5 ("Public Utility as Theme Park") of Philip Stevick's *Imagining Philadelphia: Travelers' Views of the City from 1800 to the Present* (Philadelphia: University of Pennsylvania Press, 1996).

25. See Goodyear Jr., *Thomas Doughty (1793–1865)*. Nicolai Cikovsky Jr. explores the iconographic significance of the tree stump in American art at length in his article "The Ravages of the Axe: The Meaning of the Tree Stump in Nineteenth-Century American Art," *Art Bulletin* 61, No. 4 (1979): pp. 611–26.

26. Donald H. Cresswell, "Philadelphia Lithography and American Landscape," in Erika Piola, ed., *Philadelphia on Stone: Commercial Lithography in Philadelphia, 1828–1878* (University Park: The Pennsylvania State University Press, in association with the Library Company of Philadelphia, 2012), p. 215. For a detailed study of the visual culture of Philadelphia's urban environmental history and ecological dynamics, see Alan C. Braddock and Laura Turner Igoe, eds., *A Greene Country Towne: Philadelphia's Ecology in the Cultural Imagination* (University Park: The Pennsylvania State University Press, 2016), and Brian C. Black and Michael J. Chiarappa, eds., *Nature's Entrepôt: Philadelphia's Urban Sphere and Its Environmental Thresholds* (Pittsburgh: University of Pittsburgh Press, 2012).

27. For an evocative, poetic exploration of the various roles played by the Schuylkill River in Philadelphia's history, see Beth Kephart's *Flow: The Life and Times of Philadelphia's Schuylkill River* (Philadelphia: Temple University Press, 2007).

28. Joy S. Kasson, "The Voyage of Life: Thomas Cole and Romantic Disillusionment," *American Quarterly* 27, No. 1 (March 1975): pp. 42–43.

29. Ellwood C. Parry III, Paul D. Schweizer, and Dan A. Kushel, *The Voyage of Life by Thomas Cole: Paintings, Drawings, and Prints* (Utica, NY: Museum of Art, Munson-Williams-Proctor Institute, 1985), p. 5.

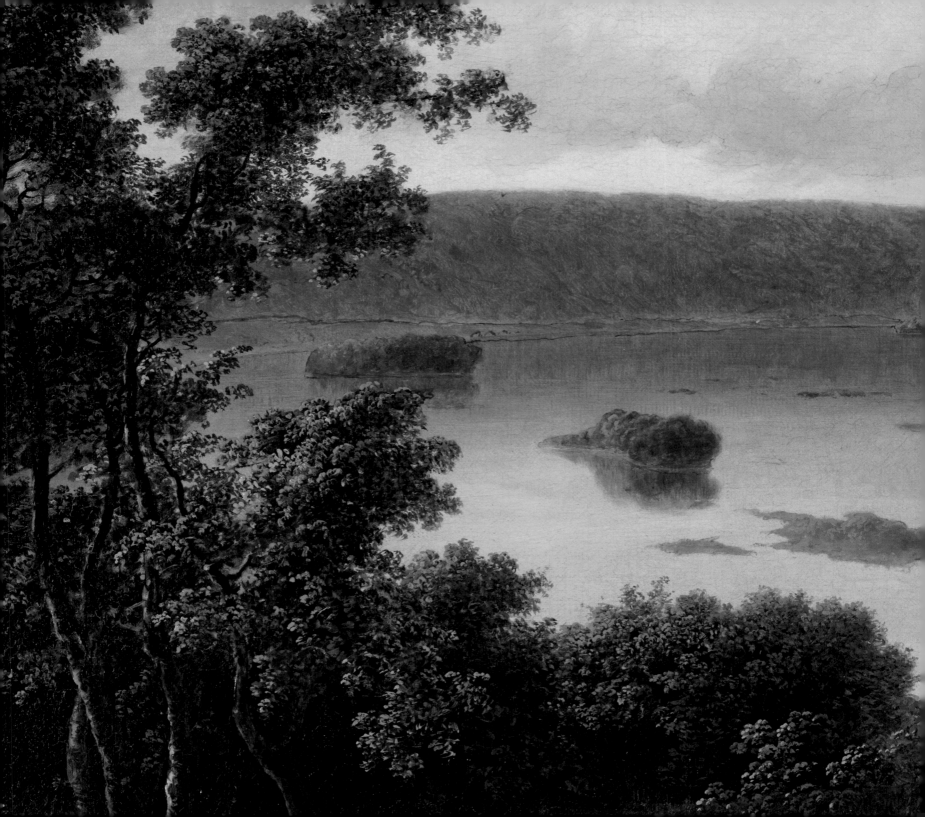

Plates

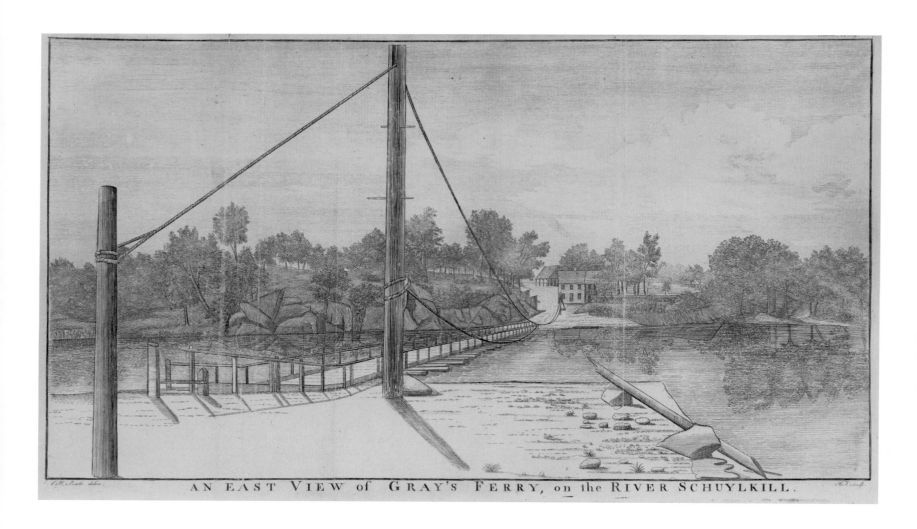

AN EAST VIEW of GRAY'S FERRY, on the RIVER SCHUYLKILL.

PLATE 1

James Trenchard (b. 1747) after
Charles Willson Peale (1741–1827)

An East View of Gray's Ferry
1787

Etching and engraving on cream laid paper,
7¼ × 13½ in. Gift of George Harding, 1957.24

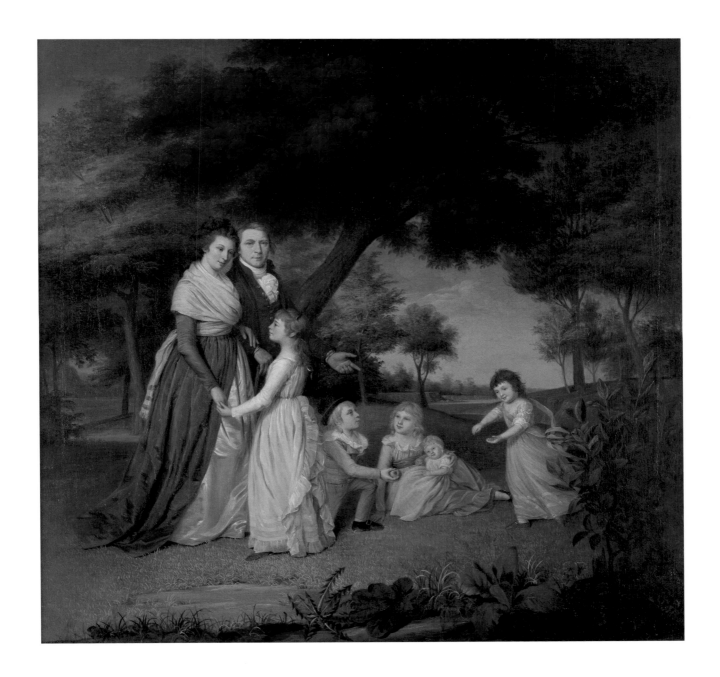

PLATE 2

The Artist and His Family

James Peale
(1749–1831)

1795

Oil on canvas, 31¼ × 32¾ in.
Gift of John Frederick Lewis, 1922.1.1

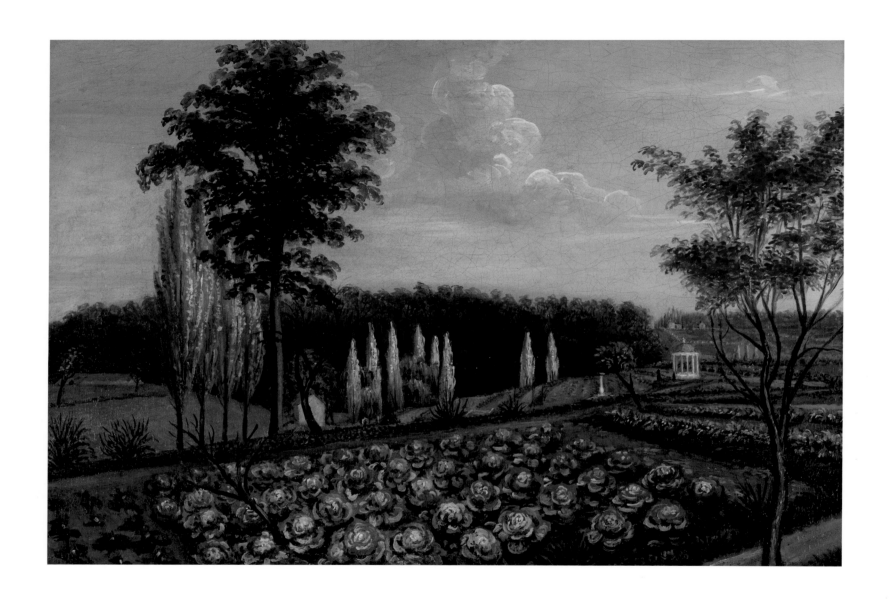

PLATE 3

Charles Willson Peale
(1741–1827)

Cabbage Patch, The Gardens of Belfield, Pennsylvania
c. 1815–16

Oil on canvas, 11⅛ × 16⅛ in.
Henry S. McNeil Fund, 2008.10

PLATE 4

William Russell Birch
(1755–1834)

Springland: The Artist's Residence
after 1798

Enamel on copper (set as a pin), 1¼ × 1⅞ in.
Bequest of Constance A. Jones, 1988.16.3

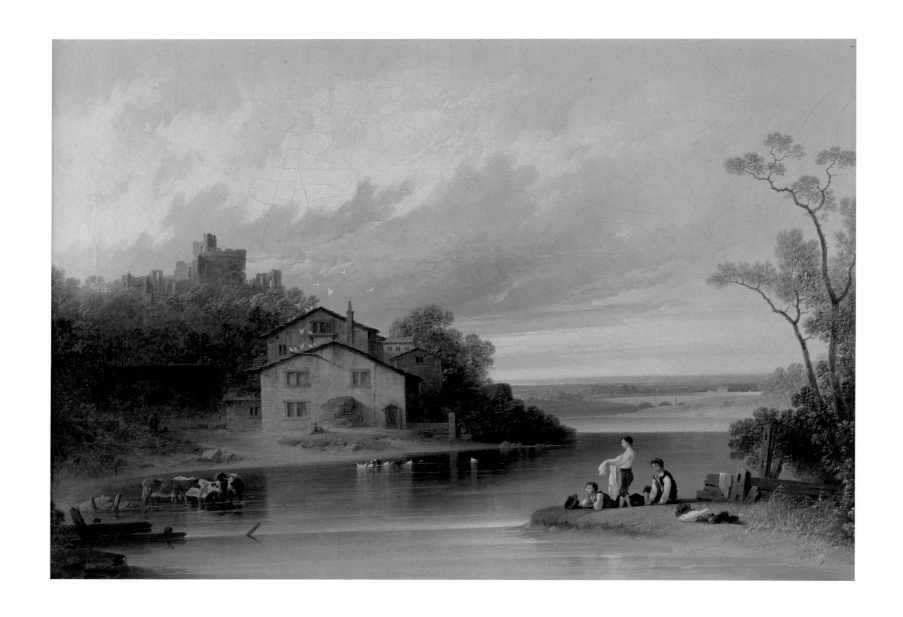

PLATE 5

Joshua Shaw
(c. 1777–1860)

Landscape with Watermill
c. 1818

Oil on canvas, 15¼ × 21¾ in.
Bequest of Henry C. Carey (The Carey Collection),
1879.8.20

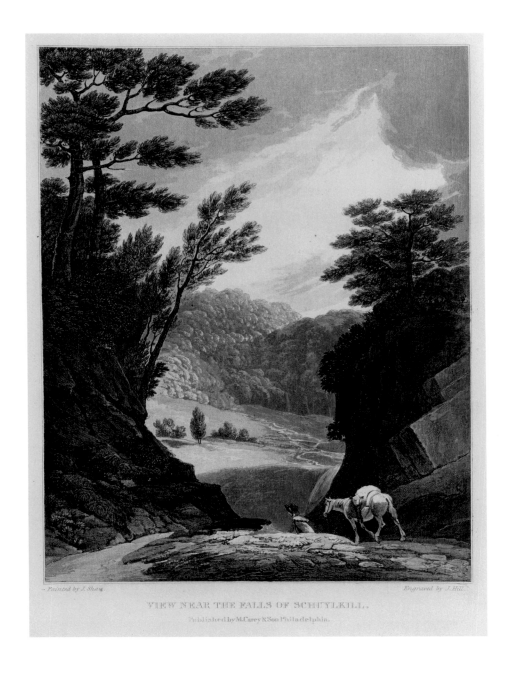

Painted by J. Shaw. Engraved by J. Hill.

VIEW NEAR THE FALLS OF SCHUYLKILL.

Published by M. Carey & Son Philadelphia.

PLATE 6

John Hill (1770–1850) after
Joshua Shaw (c. 1777–1860)

View Near the Falls of Schuylkill
1820

Etching, soft ground, aquatint on
cream wove paper, 13⅛ × 10¹⁄₁₆ in.
John S. Phillips Collection, 1876.9.335

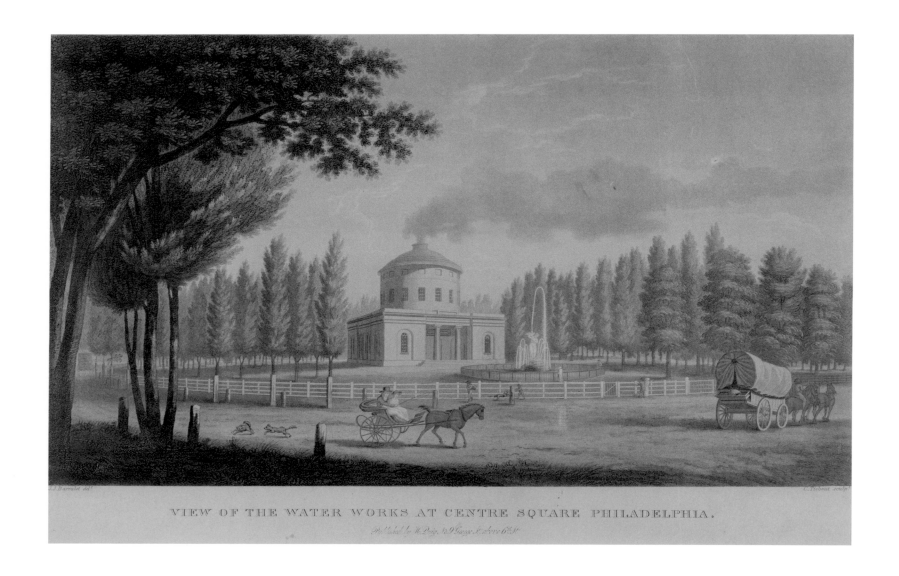

VIEW OF THE WATER WORKS AT CENTRE SQUARE PHILADELPHIA.

Published by W. Price, No.9 George St. above 6th St.

PLATE 7

Cornelius Tiebout (c. 1773–1832) after
John James Barralet (c. 1747–1815)

View of the Water Works at Centre Square Philadelphia
c. 1812

Stipple engraving on off-white wove paper,
11¾ × 20¼ in. John S. Phillips Collection,
1876.9.483

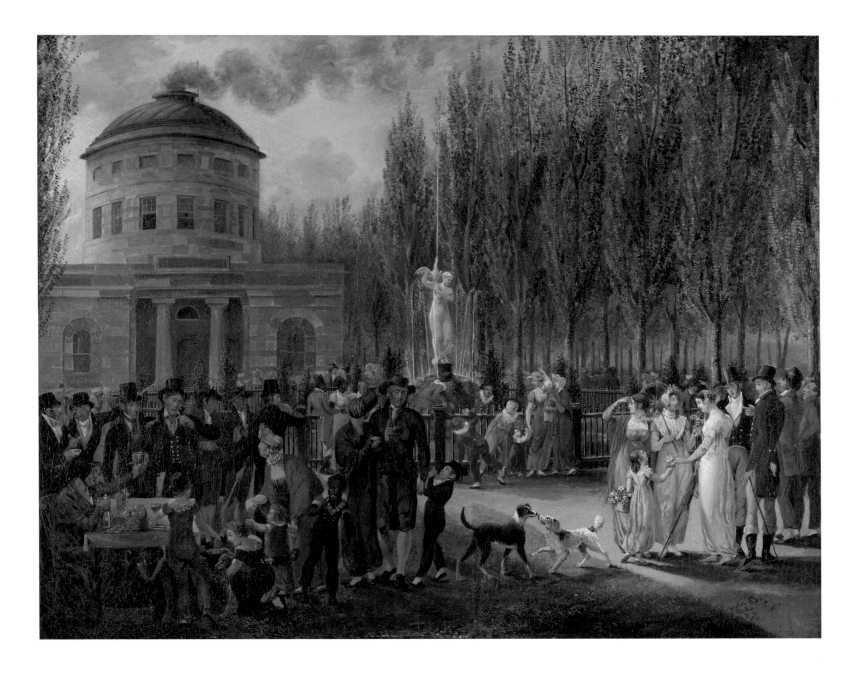

PLATE 8

John Lewis Krimmel
(1786–1821)

Fourth of July in Centre Square
by 1812

Oil on canvas, 22¾ × 29 in. Pennsylvania
Academy purchase (from the estate
of Paul Beck, Jr.), 1845.3.1

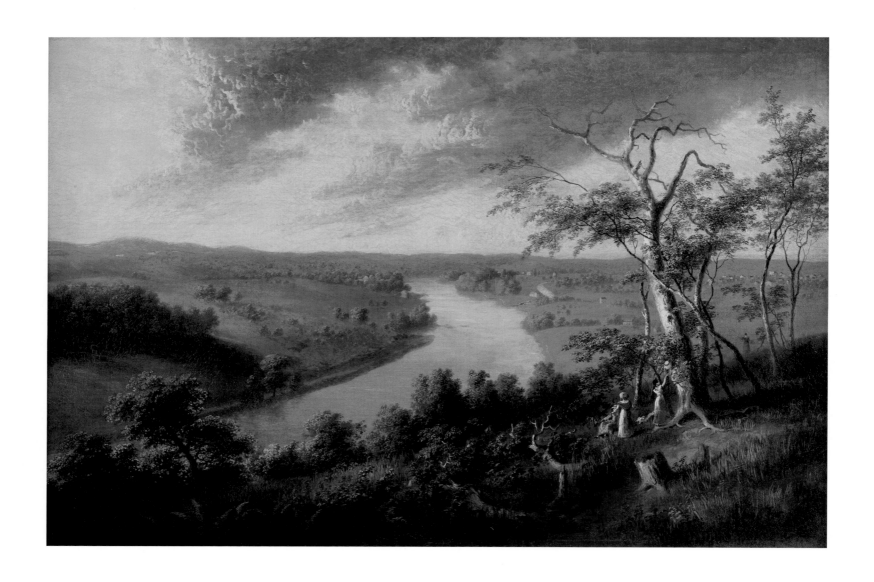

PLATE 9

Thomas Doughty
(1793–1856)

Landscape with Curving River
c. 1823

Oil on canvas, 18⁹⁄₁₆ × 27½ in. Bequest of
Henry C. Carey (The Carey Collection), 1879.8.5

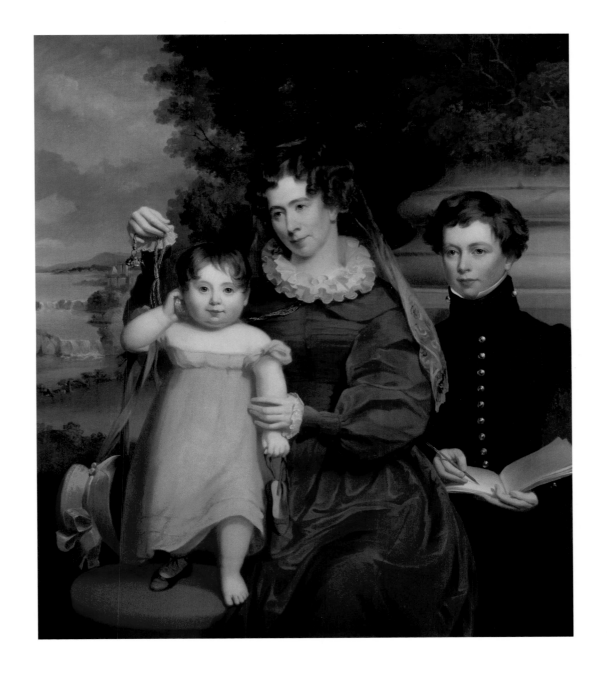

PLATE 10

Jacob Eichholtz
(1776–1842)

Mrs. Victor René Value, Her Daughter Victoria Matilda,
and Her Stepson Jesse René
c. 1830

Oil on canvas, 52⅞ × 45 in.
Gift of Mrs. Charles E. Dunbar, 1986.40

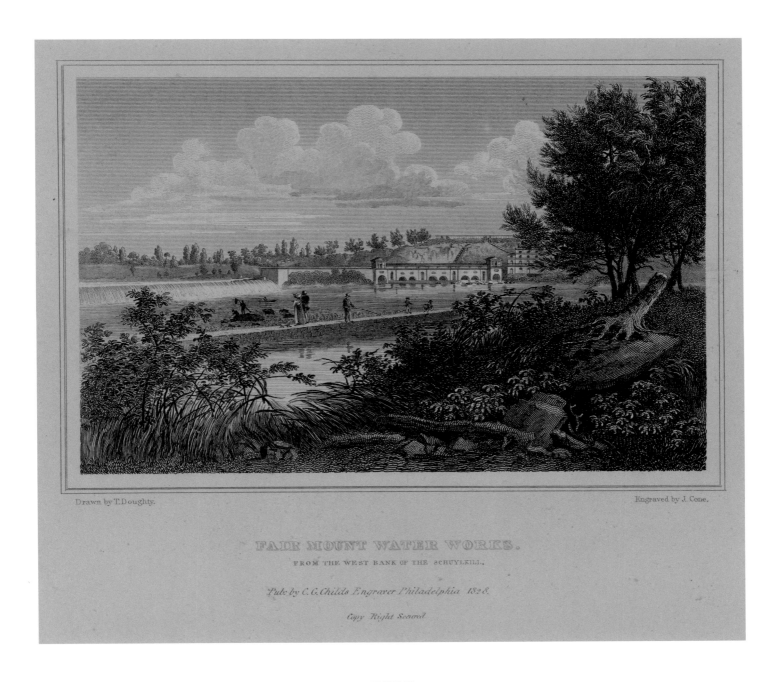

Drawn by T. Doughty.

Engraved by J. Cone.

FAIR MOUNT WATER WORKS.

FROM THE WEST BANK OF THE SCHUYLKILL.

Pub. by C.G. Childs Engraver Philadelphia 1828.

Copy Right Secured

PLATE 11

Joseph Cone (active 1814–1830) after
Thomas Doughty (1793–1856)

Fair Mount Water Works
1828

Etching and engraving on white wove paper,
3⁷⁄₁₆ × 5¹⁄₁₆ in. John S. Phillips Collection,
1876.9.129

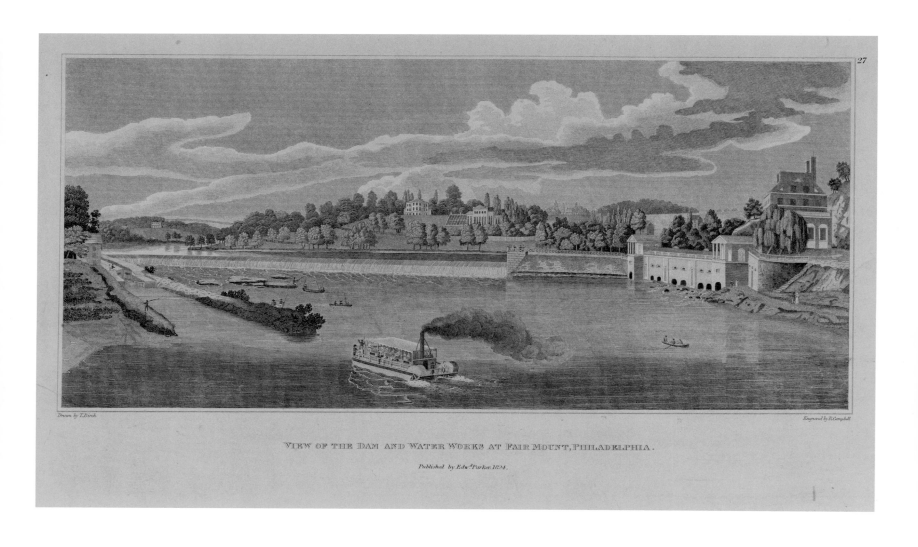

Drawn by T.Birch. Engraved by R.Campbell.

VIEW OF THE DAM AND WATER WORKS AT FAIR MOUNT, PHILADELPHIA.

Published by Edwd Parker. 1824.

PLATE 12

Robert Campbell (active 1806–1831)
after Thomas Birch (1779–1851)

View of the Dam and Waterworks at Fairmount, Philadelphia
1824

Engraving and etching on tan wove paper,
6¾ × 14⅝ in. Source unknown, 1956.31b

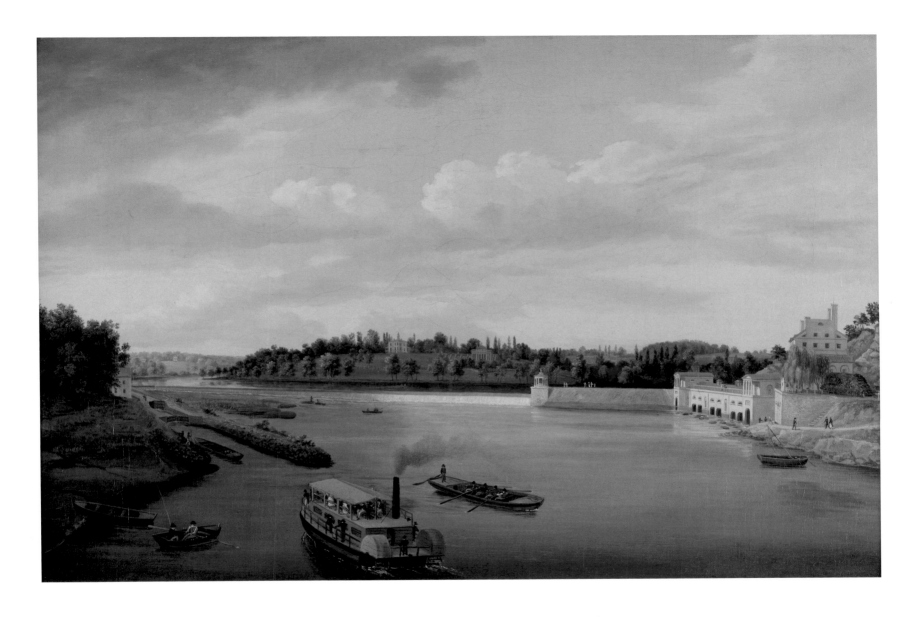

PLATE 13

Thomas Birch
(1779–1851)

Fairmount Water Works
1821

Oil on canvas, 20⅛ × 30¹⁄₁₆ in.
Bequest of Charles Graff, 1845.1

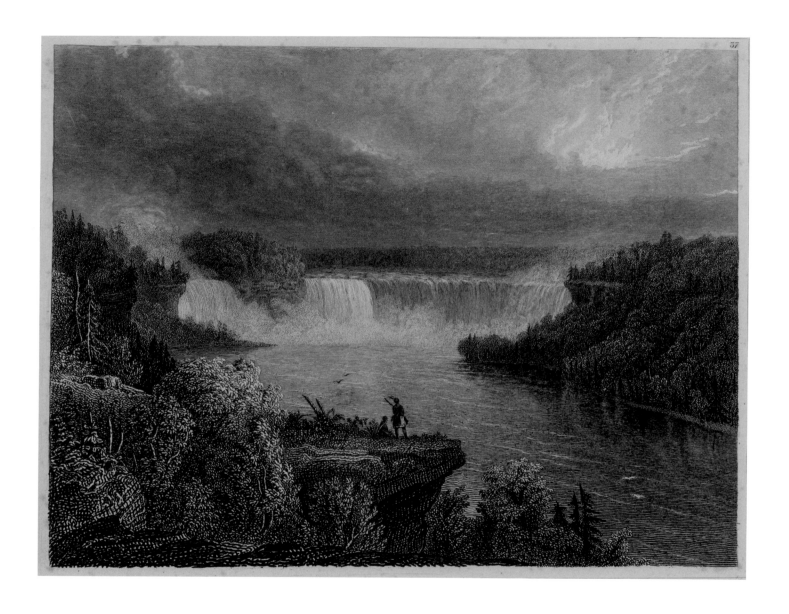

PLATE 14

Fenner, Sears & Co. after
Thomas Cole (1801–1848)

[A Distant View of the Falls of Niagara]
1831

Etching and engraving on white wove paper,
4⅜ × 5½ in. John S. Phillips Collection,
1876.9.121

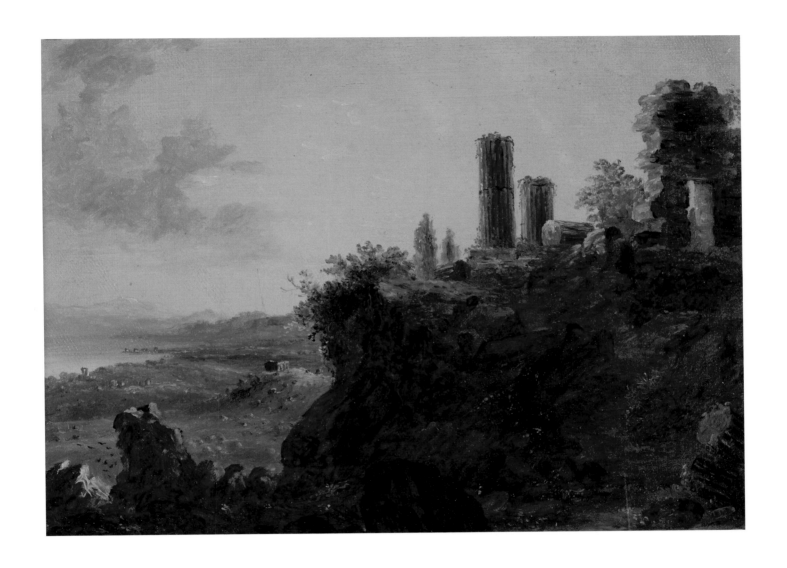

Thomas Cole
(1801–1848)

View of Sicily
c. 1842–45

Oil on wood panel, 7⁵⁄₁₆ × 10⅛ in.
Mr. and Mrs. Edward H. Coates Fund, 2011.22

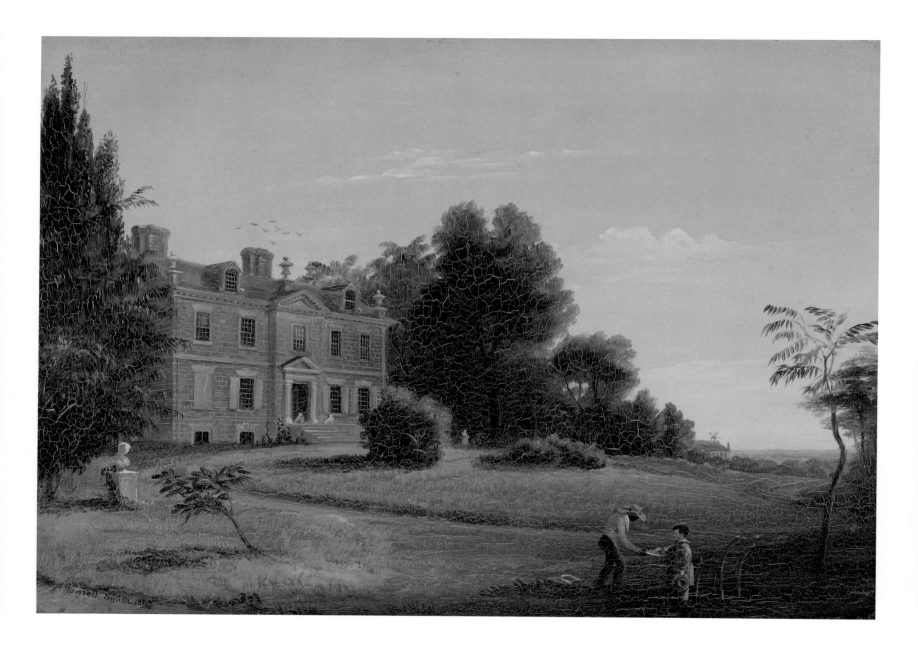

PLATE 16

Russell Smith
(1812–1896)

Chew House, Germantown
1843

Oil on wood, 16¹³⁄₁₆ × 24 in.
Gift of the artist, 1845.4

PLATE 17

Unidentified artist

Laurel Hill Cemetery Gate, Philadelphia
c. 1840

Oil on canvas, 16 × 24⅛ in.
Gift of Mrs. Edgar P. Richardson, 1986.29.5

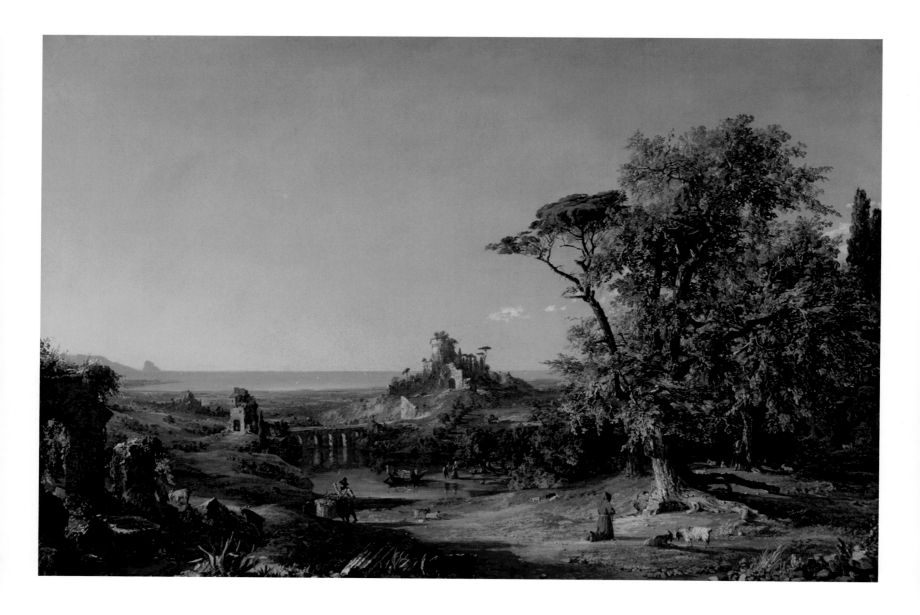

PLATE 18

Jasper Francis Cropsey
(1823–1900)

Landscape with Figures Near Rome
1847

Oil on canvas, 27⁵⁄₁₆ × 40³⁄₁₆ in.
Gift of John Frederick Lewis, Jr., 1954.22.1

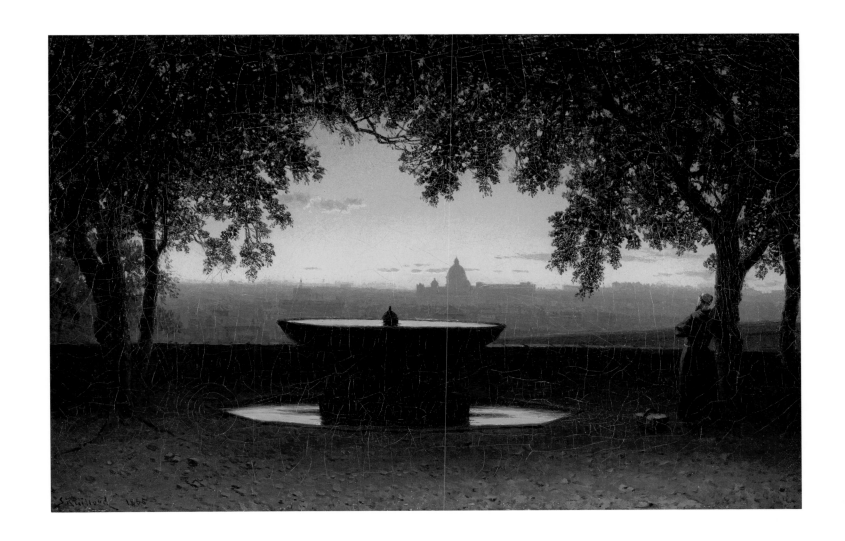

Sanford Robinson Gifford
(1823–1880)

Saint Peter's from Pincian Hill
1865

Oil on canvas, 9¹³⁄₁₆ × 15⁹⁄₁₆ in.
Gift of Mr. and Mrs. Edward Kesler, 1975.20.3

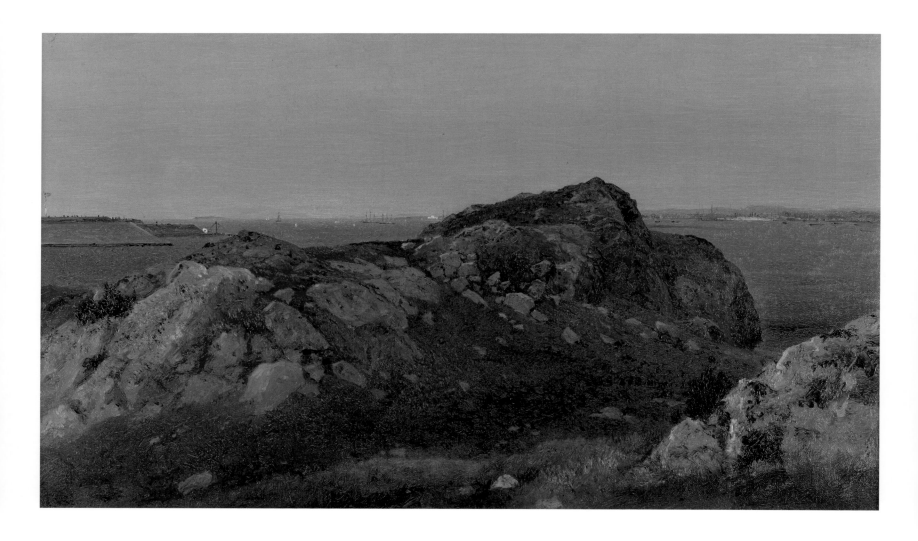

PLATE 20

John Frederick Kensett
(1816–1872)

At Newport, Rhode Island
c. 1855

Oil on canvas, 12 × 20 in.
Gift of Mr. and Mrs. Edward Kesler, 1975.20.4

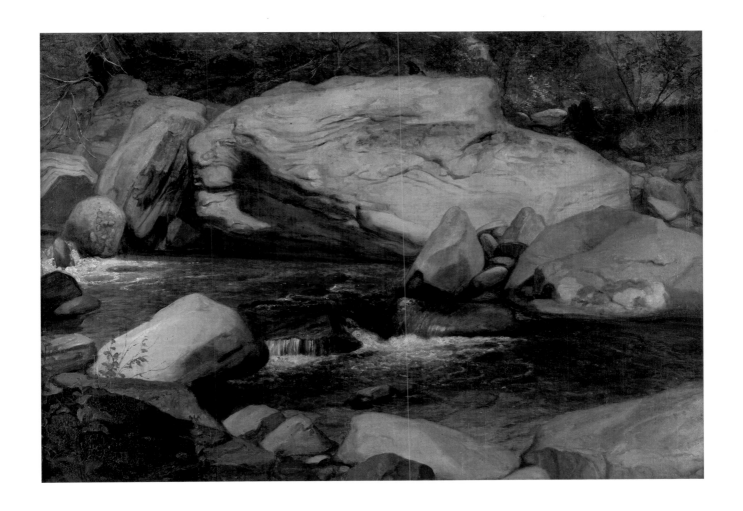

PLATE 21

Asher Brown Durand
(1796–1886)

Landscape: Creek and Rocks
1850s

Oil on canvas, 16¹⁵⁄₁₆ × 24 in.
Gift of Charles Henry Hart, 1915.9

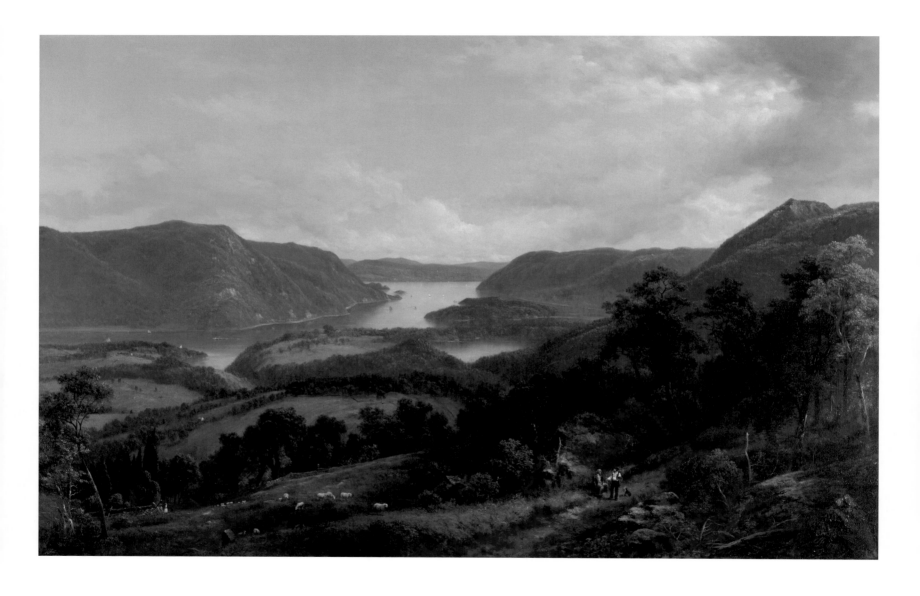

PLATE 22

David Johnson
(1827–1908)

The Hudson River from Fort Montgomery
1870

Oil on canvas, 38½ × 60 in.
Museum Purchase, 2016.12

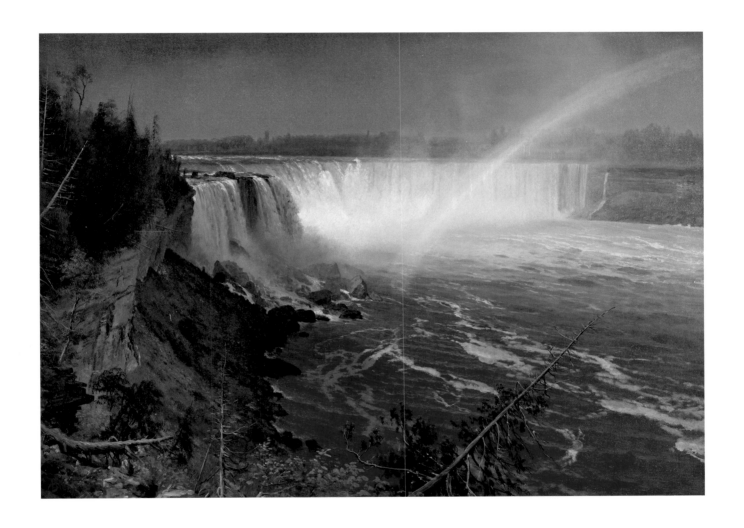

Albert Bierstadt
(1830–1902)

Niagara
1869

Oil on paper laid down on canvas, 19 × 27 in.
Joseph E. Temple Fund, 2015.18

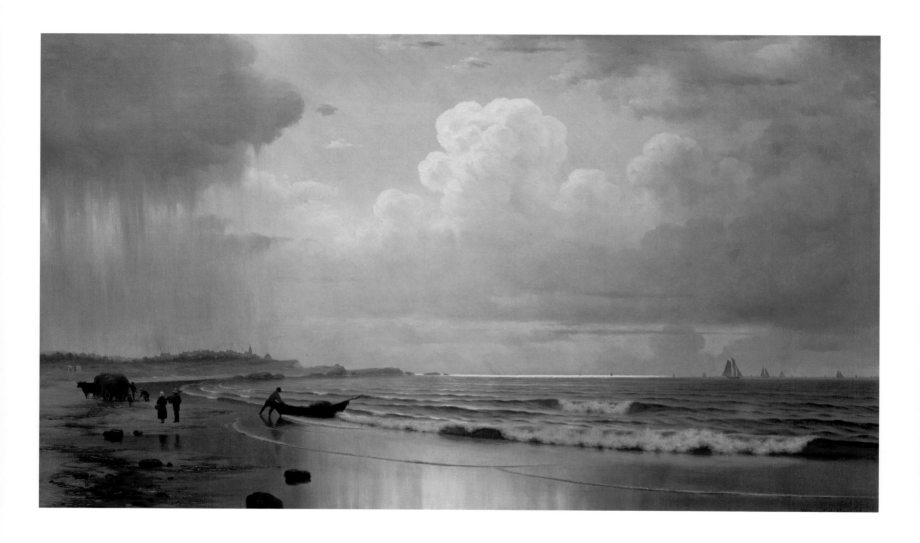

PLATE 24

William Frederick de Haas
(1830–1880)

Biddeford Beach, Coast of Maine
1875

Oil on canvas, 30½ × 51 in.
Joseph E. Temple Fund, 2015.20

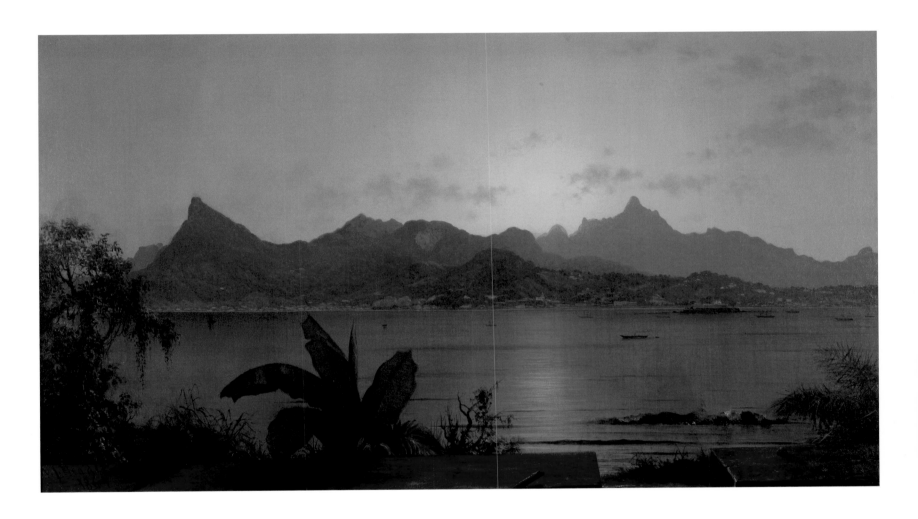

PLATE 25

Martin Johnson Heade
(1819–1904)

Sunset Harbor at Rio
1864

Oil on canvas, 20⅛ × 35 in.
Henry D. Gibson Fund, 1985.10

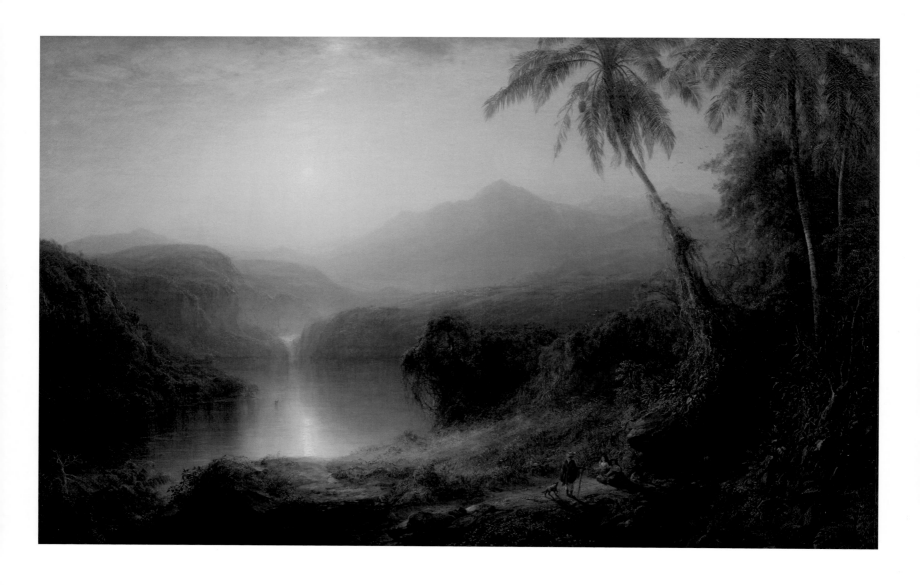

PLATE 26

Frederic Edwin Church
(1826–1900)

Valley of Santa Ysabel, New Granada
1875

Oil on canvas, 39¼ × 60 in.
Museum Purchase, 2018.10

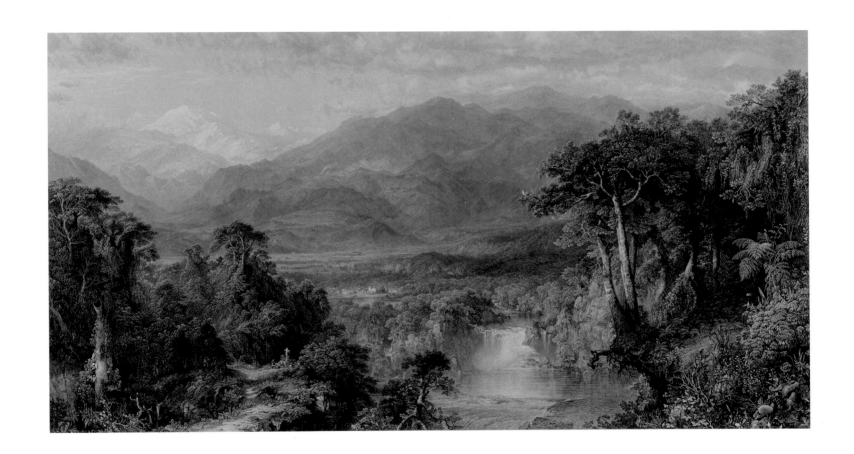

PLATE 27

William Forrest (1805–1889) after
Frederic Edwin Church (1826–1900)

The Heart of the Andes
1862

Engraving, etching, stipple on chine collé
on cream wove paper, 13½ × 24⅞ in.
The John T. Morris Collection, 1985.x.199

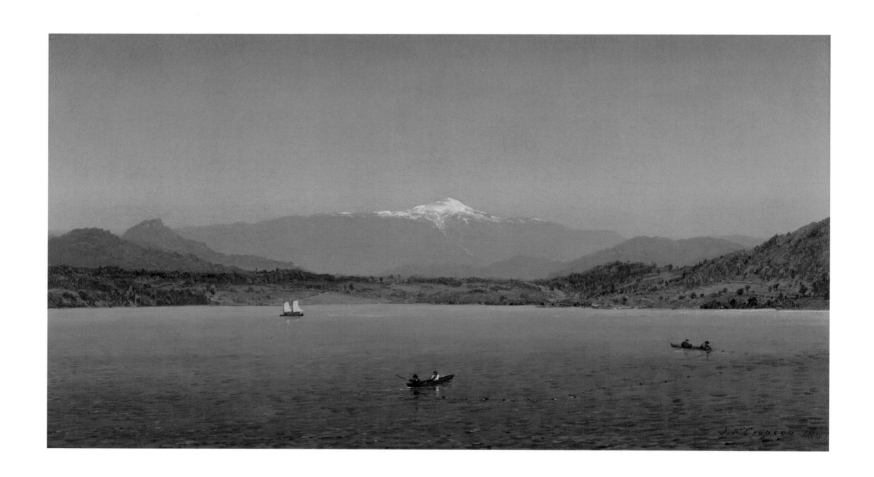

PLATE 28

Jasper Francis Cropsey
(1823–1900)

Mount Washington from Lake Sebago, Maine
1867

Oil on canvas, 10¹⁄₁₆ × 18⅛ in.
Gift of Mr. and Mrs. Edward Kesler, 1975.20.5

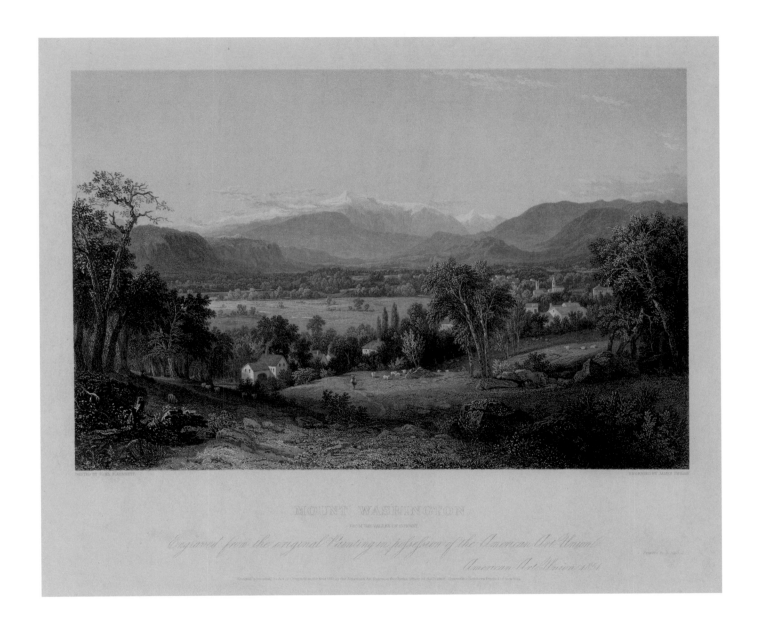

MOUNT WASHINGTON

FROM THE VALLEY OF CONWAY

Engraved from the original Painting in possession of the American Art Union

American Art Union 1851

PLATE 29

James Smillie (1807–1885) after
John Frederick Kensett (1816–1872)

Mount Washington
1851

Steel engraving on off-white wove paper, 7 × 10⅜ in.
John S. Phillips Collection, 1984.x.295

PLATE 30

Thomas Moran
(1837–1926)

Two Women in the Woods
1870

Oil on canvas, 20 × 30 in. Orton P. Jackson Fund
in memory of Emily Penrose Jackson, 2015.19

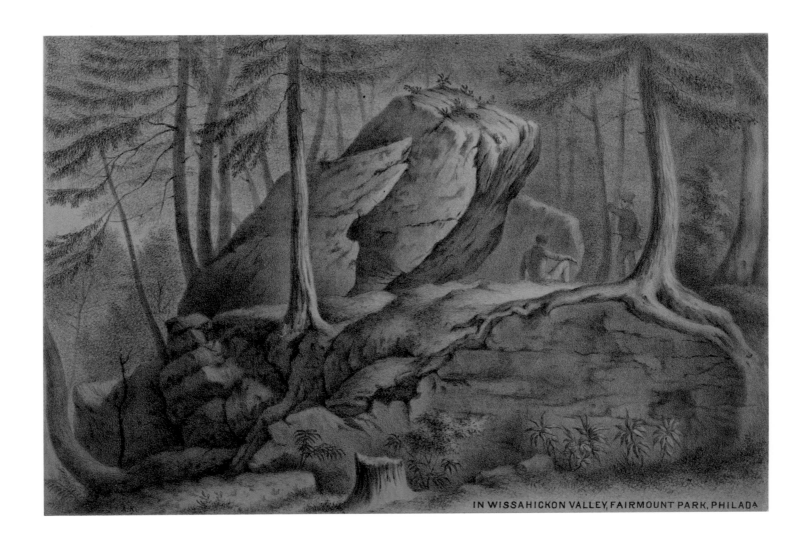

IN WISSAHICKON VALLEY, FAIRMOUNT PARK, PHILADA

Augustus Köllner
(1813–1906)

In Wissahickon Valley
1876

Chromolithograph (rainbow roll) on
cream wove paper, 6½ × 9⁷⁄₁₆ in.
John S. Phillips Collection, 1984.x.137h

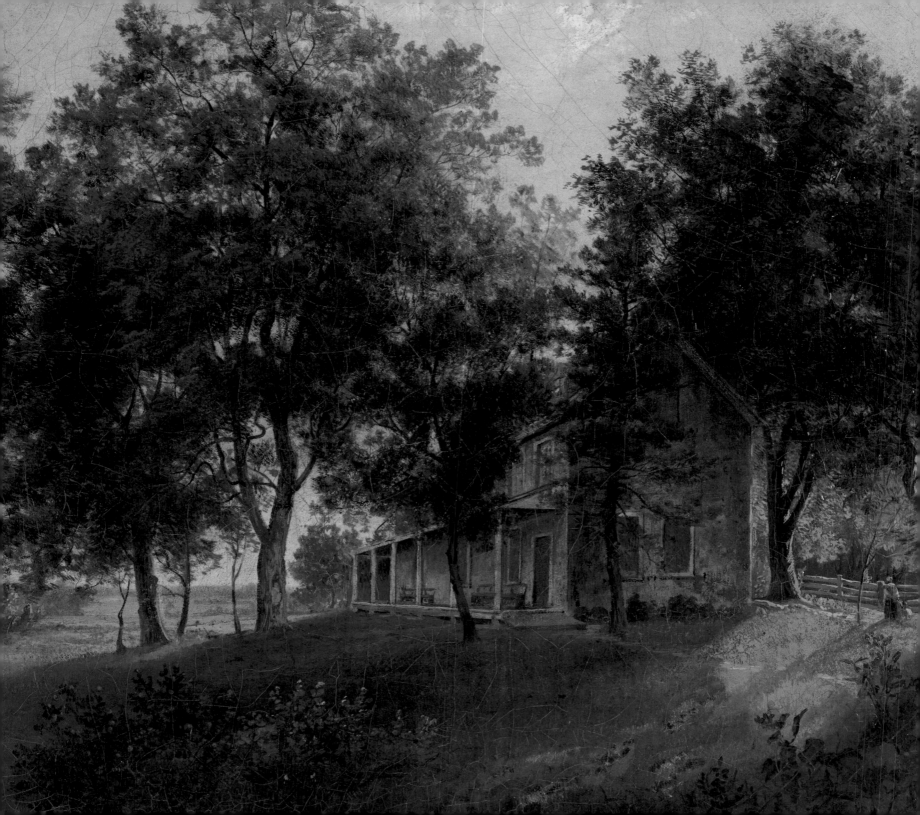

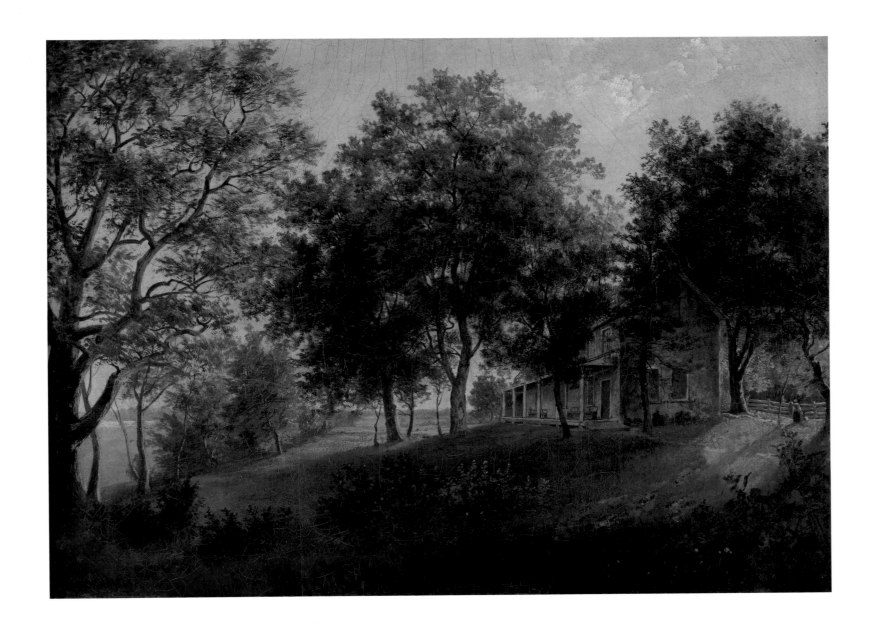

PLATE 32

Paschall Homestead at Gibson's Point, Philadelphia
1857

William Trost Richards
(1833–1905)

Oil on canvas, 18¼ × 24⅜ in.
Gift of Ann Paschall, 1931.11

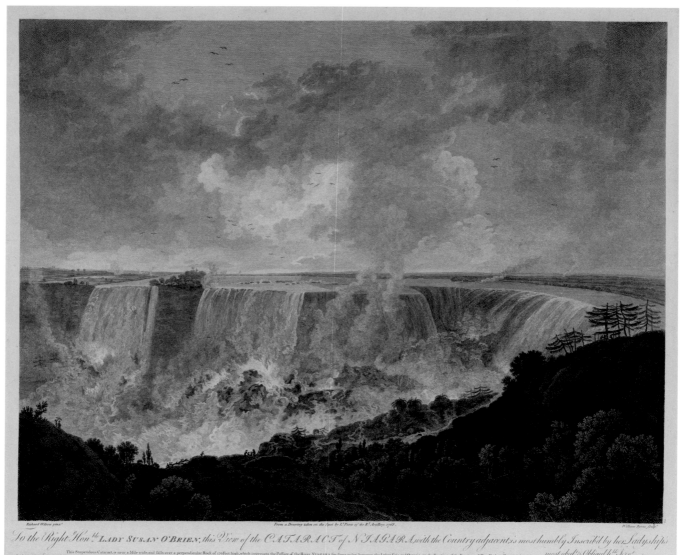

Richard Wilson pinx.ᵗ

From a Drawing taken on the Spot by Lᵗ Pierie of the Rᵗ Artillery. 1768.

William Byrne, Sculp.ᵗ

To the Right Honᵇˡᵉ LADY SUSAN O'BRIEN, this View of the CATARACT of NIAGARA, with the Country adjacent, is most humbly Inscribed by her Ladyships

most obedᵗ, Obliged hᵇˡᵉ Serᵗ.

This Stupendous Cataract is near a Mile wide, and falls over a perpendicular Rock of 170 Feet high, which interrupts the Passage of the River NIAGARA for some miles, between the Lakes Erie and Ontario, on the Frontiers of the Province of New York in NORTH AMERICA.

Published according to Act of Parliament, ad Feb. 1774. by the Author, and sold for him at Mʳ Bowles's, Pall Mall, and Mʳ Kitson's, in the Strand.

Size of the Picture 3 by 5.

Willᵐ Pierie

PLATE 33

William Byrne (1743–1805) after
Richard Wilson (1714–1782) after
Lt. William Pierie (active late 1700s)

Cataract of Niagara
1774

Engraving, etching, stipple on cream laid paper,
16⅜ × 20⁹⁄₁₆ in. John S. Phillips Collection,
1985.x.712

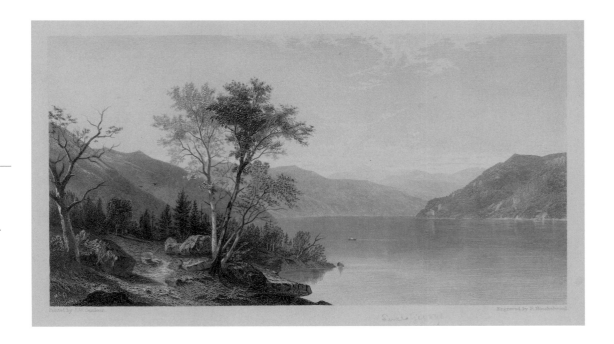

PLATE 34

[Lake George]
1870

Robert Hinshelwood (1812–after 1875) after
John William Casilear (1811–1893)

Etching and engraving on cream wove paper, 4¹³⁄₁₆ × 8⁷⁄₈ in.
John S. Phillips Collection, 1876.9.336

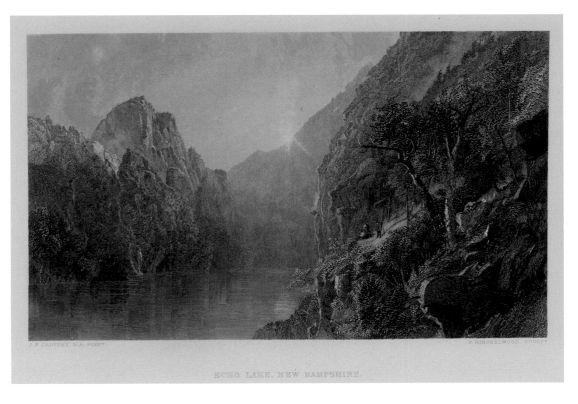

PLATE 35

Echo Lake, New Hampshire
c. 1850–60

Robert Hinshelwood (1812–after 1875) after
Jasper Francis Cropsey (1823–1900)

Steel engraving on off-white wove paper,
5⁷⁄₈ × 9¹⁵⁄₁₆ in. Pennsylvania Academy
of the Fine Arts Library, 1984.x.1

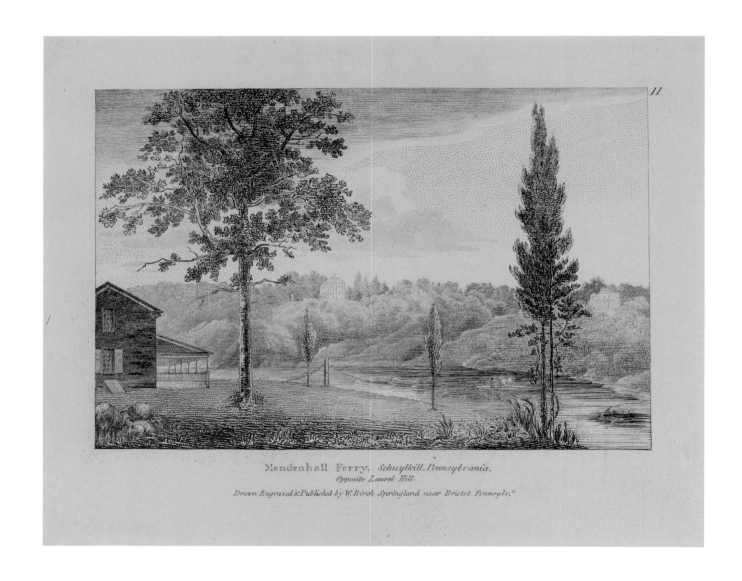

Mendenhall Ferry, *Schuylkill, Pennsylvania.*
Opposite Laurel Hill.
Drawn Engraved & Published by W. Birch Springland near Bristol Pennsylv.ᵃ

PLATE 36

William Russell Birch
(1755–1834)

Mendenhall Ferry, Schuylkill, Pennsylvania
1808

Etching, engraving, stipple on
ivory wove paper, 4 × 5¹⁵⁄₁₆ in.
John S. Phillips Collection, 1876.9.18d

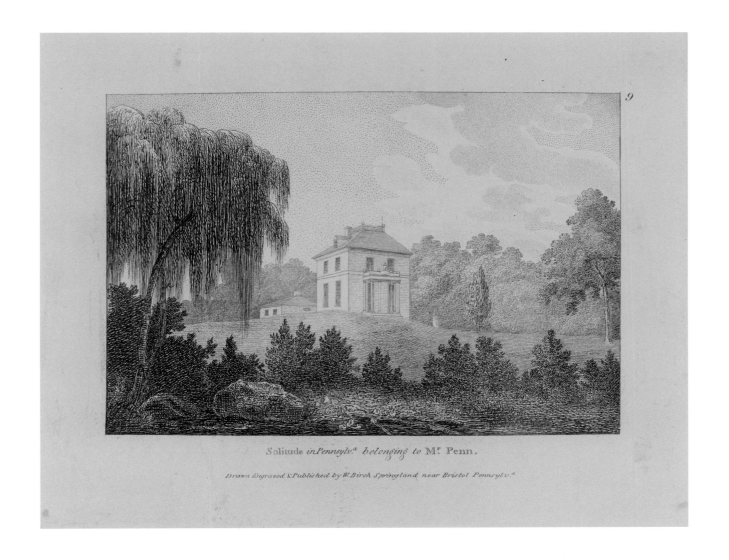

Solitude in Pennsylv.ᵃ belonging to Mᵣ. Penn.

Drawn Engraved & Published by W. Birch Springland near Bristol Pennsylvᵃ.

PLATE 37

William Russell Birch
(1755–1834)

Solitude in Pennsylva. belonging to Mr. Penn
1808

Etching, engraving, stipple on white wove paper,
4 × 5¹³⁄₁₆ in. John S. Phillips Collection, 1876.9.19d

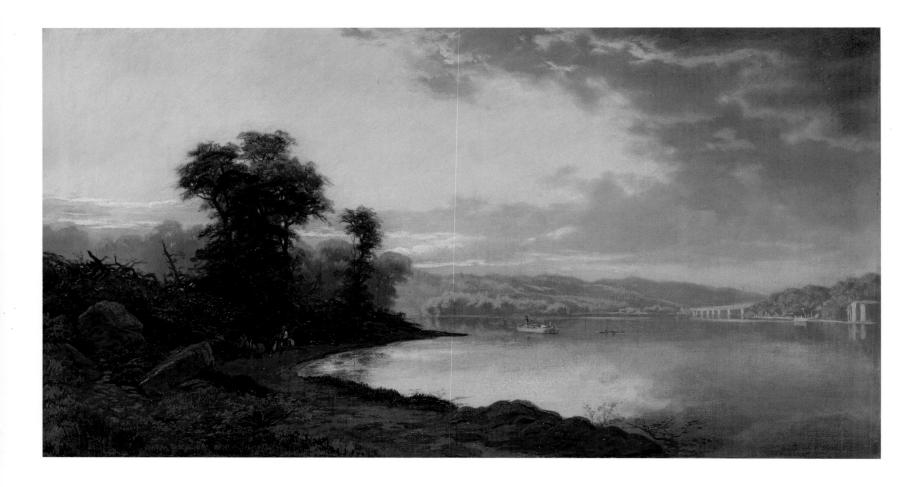

PLATE 38

T. J. Fenimore
(1842–1873)

Schuylkill River
c. 1869

Oil on canvas, 12⅜ × 22⅜ in.
Gift of Mr. and Mrs. J. Welles Henderson,
1976.24.2

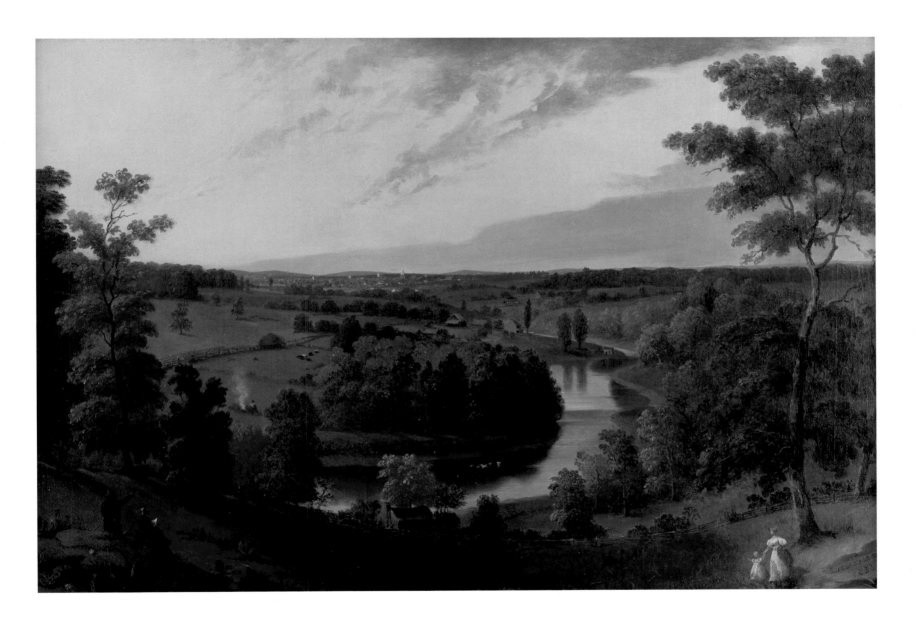

PLATE 39

Jacob Eichholtz
(1776–1842)

Conestoga Creek and Lancaster
1833

Oil on canvas, 20¼ × 30¼ in.
Gift of Mrs. James H. Beal, 1961.8.10

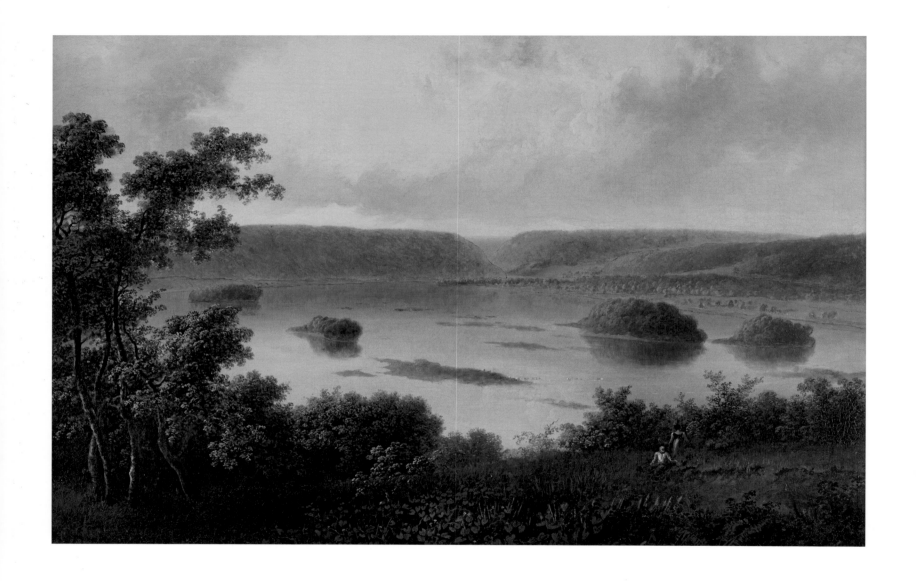

PLATE 40

Thomas Doughty
(1793–1856)

View on the Susquehanna near Harrisburg
c. 1830

Oil on canvas, 18⁹⁄₁₆ × 27⁹⁄₁₆ in.
Source unknown, 1844.1

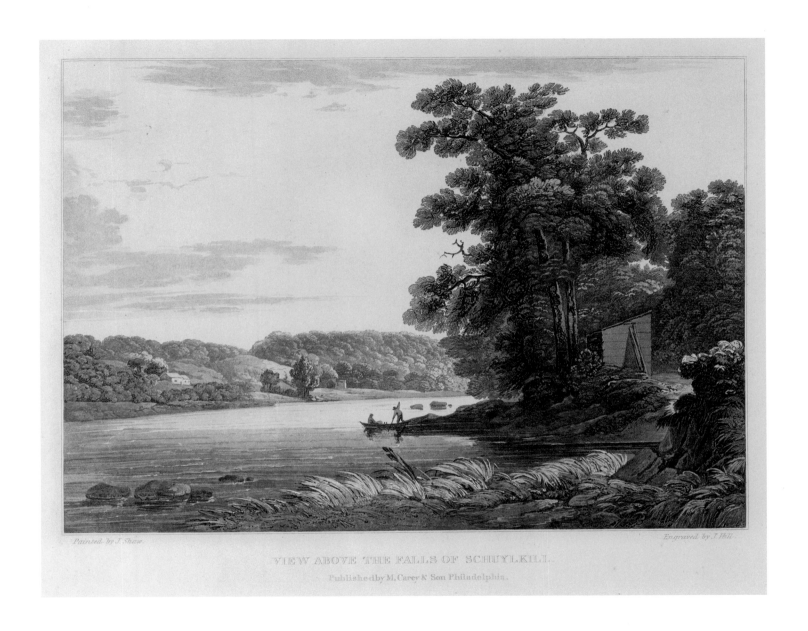

Painted by J. Shaw.

Engraved by J. Hill.

VIEW ABOVE THE FALLS OF SCHUYLKILL.

Published by M. Carey & Son Philadelphia.

PLATE 41

John Hill (1770–1850) after
Joshua Shaw (c. 1777–1860)

View Above the Falls of Schuylkill
1820

Etching, soft ground, aquatint on
cream wove paper, 11⅞ × 15⅜ in.
John S. Phillips Collection, 1876.9.334

71

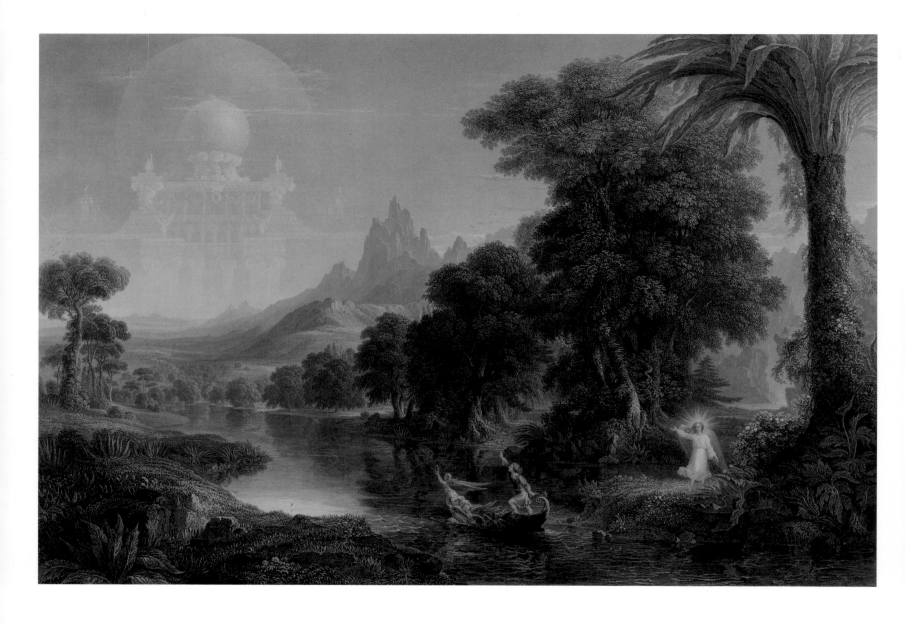

PLATE 43

James Smillie (1807–1885) after
Thomas Cole (1801–1848)

The Voyage of Life: Youth
c. 1850–60

Etching and engraving on buff wove paper,
15�5/16 × 22¾ in. John S. Phillips Collection,
1981.x.112

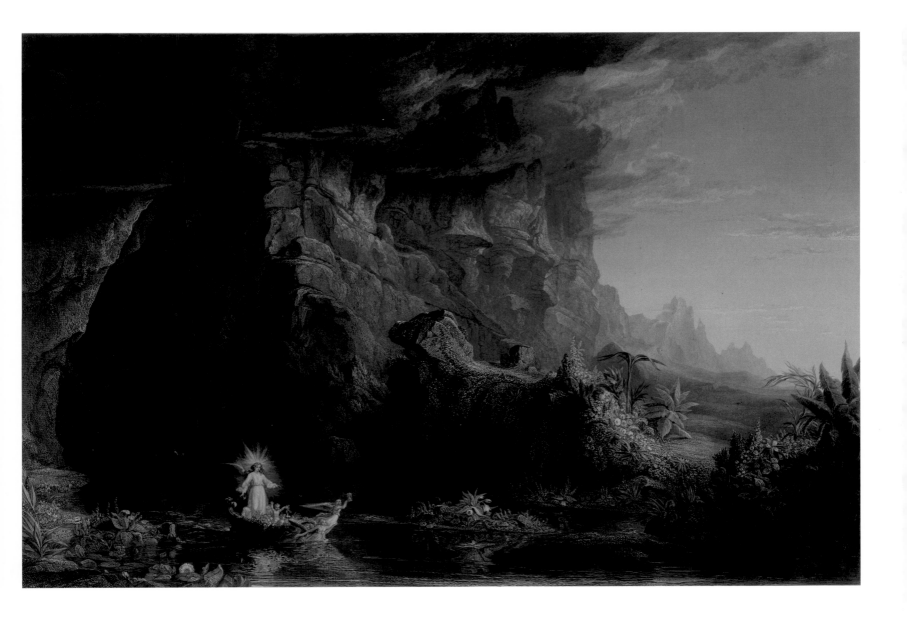

PLATE 42

James Smillie (1807–1885) after
Thomas Cole (1801–1848)

The Voyage of Life: Childhood
c. 1850–60

Etching and engraving on chine collé,
15⁷⁄₁₆ × 20¹¹⁄₁₆ in. John S. Phillips Collection,
1981.x.111

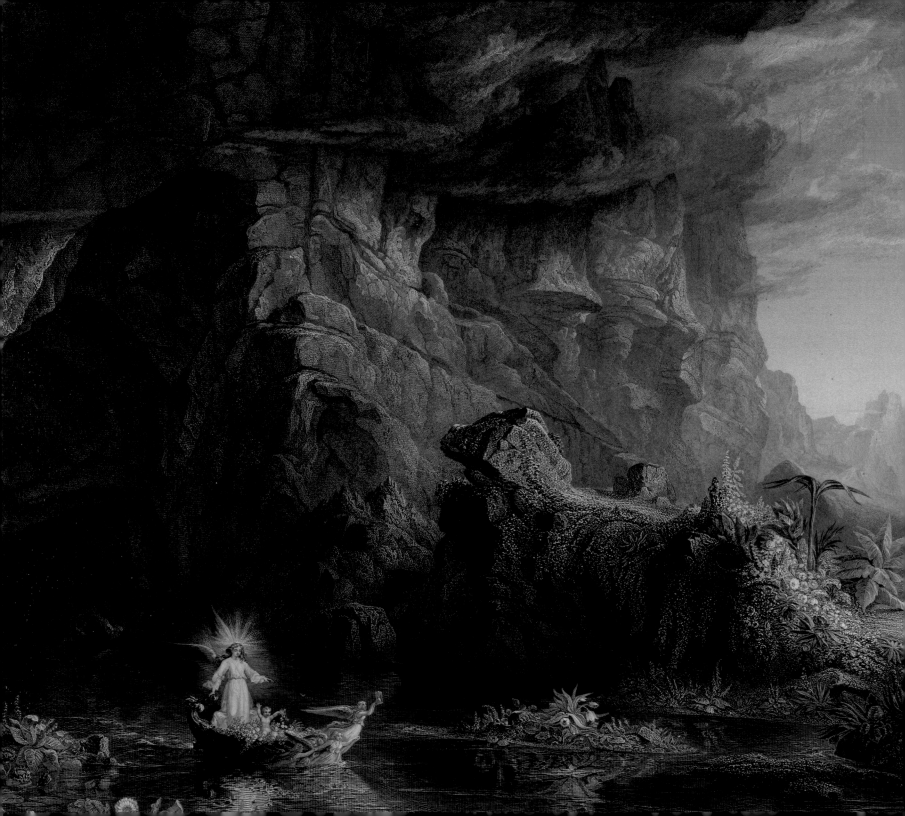

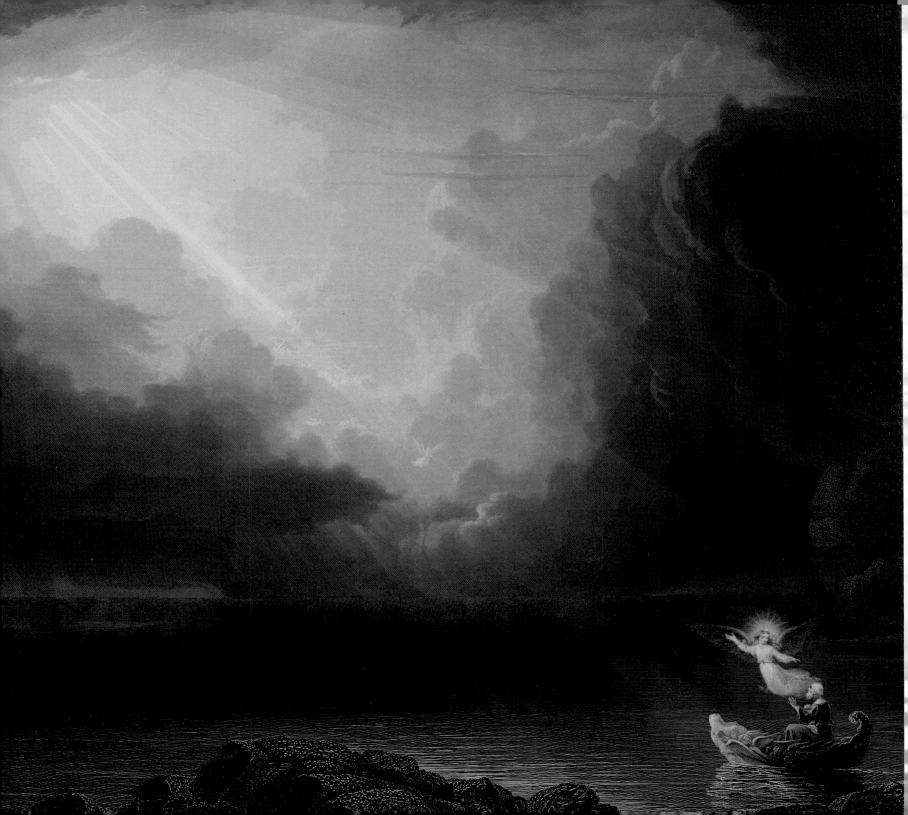

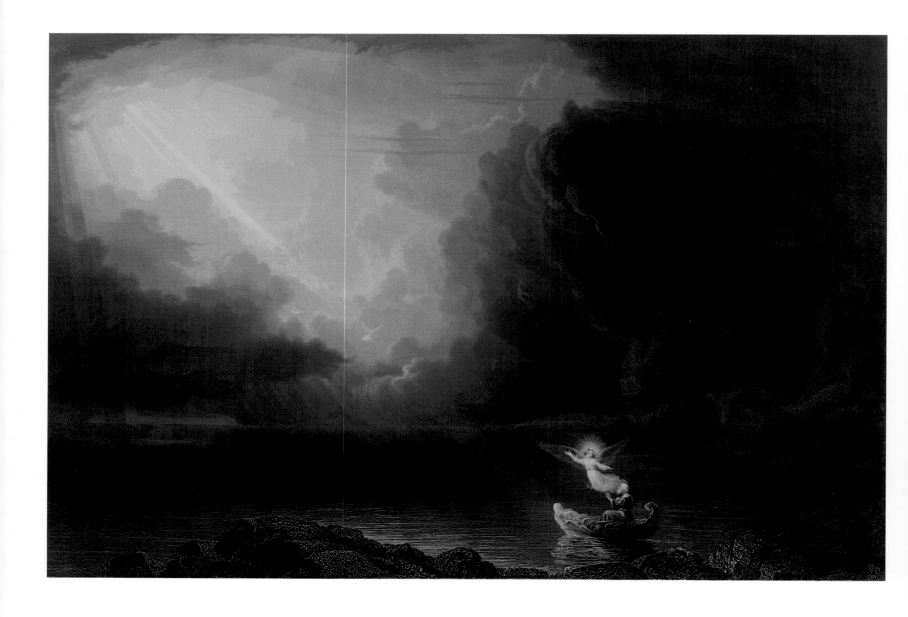

PLATE 45

James Smillie (1807–1885) after
Thomas Cole (1801–1848)

The Voyage of Life: Old Age
1856

Etching, engraving, stipple on chine collé
on white wove paper, 15¼ × 22⅝ in.
John S. Phillips Collection, 1981.x.113

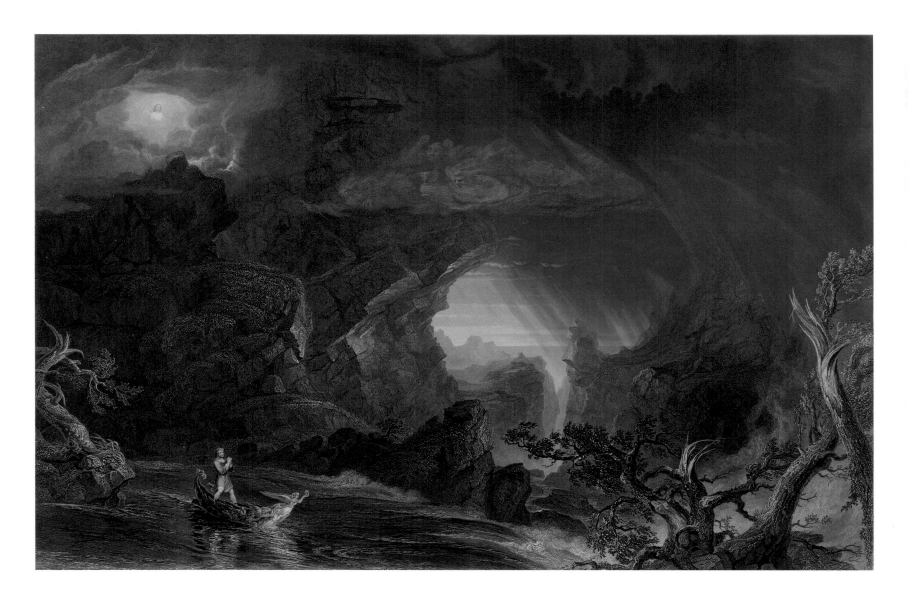

PLATE 44

James Smillie (1807–1885) after
Thomas Cole (1801–1848)

The Voyage of Life: Manhood
1856

Etching and engraving, 15¼ × 22⅝ in.
Museum Purchase, 2018.1

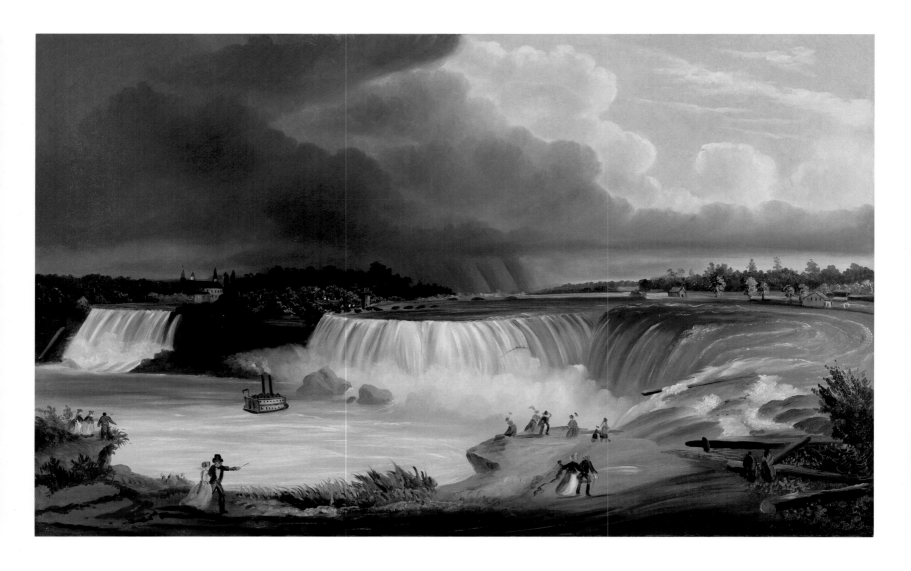

PLATE 46

Unidentified artist

Niagara Falls
c. 1845

Oil on canvas, 23½ × 37⅜ in.
Gift of Mr. and Mrs. J. Welles Henderson,
1976.24.1

PLATE 47

William Russell Birch
(1755–1834)

Falls of Niagara
by 1827

Enamel on copper, 2½ × 2¼ in.
Bequest of Eliza Howard Burd, 1860.1

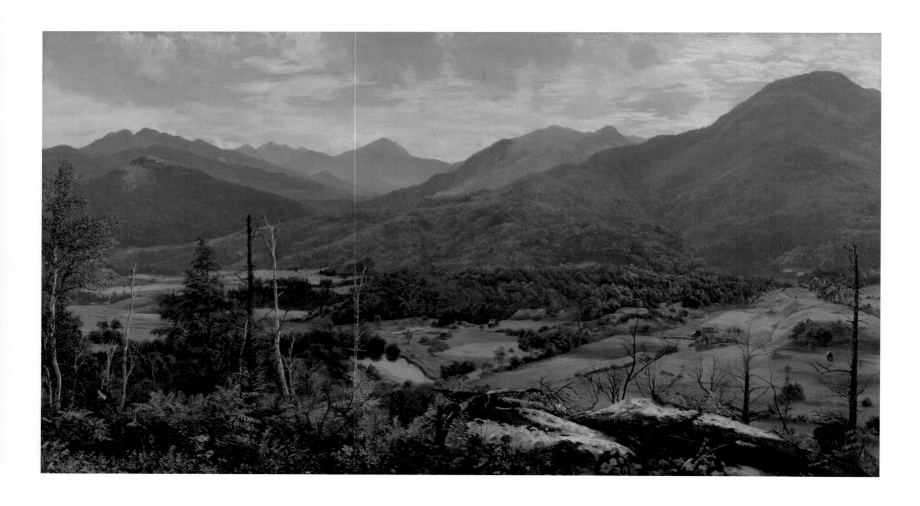

PLATE 48

David Johnson
(1827–1908)

Mount Marcy, New York
c. 1865

Oil on canvas, 16¹⁄₁₆ × 30¹⁄₁₆ in.
Gift of Mr. and Mrs. Edward Kesler, 1975.20.6

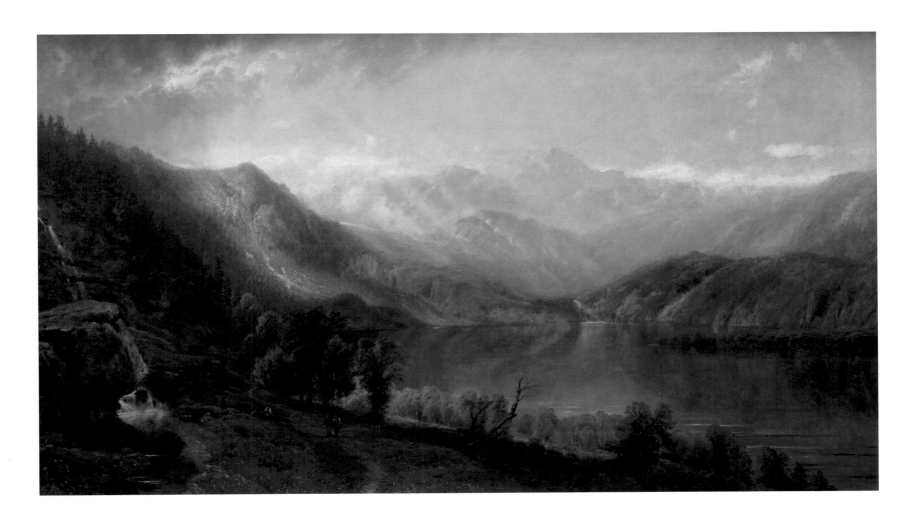

PLATE 49

Edmund Darch Lewis
(1835–1910)

Lake Willoughby
1867

Oil on canvas, 46 × 80 in.
Gift of Mr. and Mrs. William W. Jeanes, 1974.3

Acknowledgments

Neither this catalogue nor the exhibition, *From the Schuylkill to the Hudson: Landscapes of the Early American Republic*, would have been possible without the support of the invaluable partners and friends of the Pennsylvania Academy of the Fine Arts (PAFA). The exhibition celebrates the culmination of ten years spent collecting Hudson River landscape paintings as a complement to PAFA's historic strength in Schuylkill River paintings, and for their assistance over these years I would like to thank Michael Altman, Eric Baumgartner, Tom Colville, Debra Force, Andrew Schoelkopf, Richard Rossello, and the PAFA Board of Trustees.

David R. Brigham, PAFA president and CEO, along with Brooke Davis Anderson, Edna S. Tuttleman Director of the Museum, have been unflagging in their support of this project. Julie and James Alexandre, Richard Snowden, Jamie and Kristen Biddle, Louisa C. Duemling, David and Laura Grey, Burn and Susan Oberwager, and Ken and Dorothy Woodcock also provided essential support, assistance, and encouragement. Thank you all. I am also immensely grateful to PAFA's many generous patrons and join Brooke in expressing our deepest appreciation for your support of this exhibition and publication. Our thanks also go to the chairs of PAFA's museum committees, J. Brien Murphy, James C. Biddle, Emily Cavanagh, and Winston I. Lowe, for their commitment and continuing support of our many diverse exhibitions.

Many esteemed colleagues provided scholarly counsel and thoughtful support: my sincere thanks to David Barquist, the H. Richard Dietrich Jr. Curator of American Decorative Arts, and Shelley Langdale, the Park Family Associate Curator of Prints and Drawings, at the Philadelphia Museum of Art; Sarah Weatherwax, curator of prints and photographs at The Library Company of Philadelphia; Stacey Swigert, collections manager at the Philadelphia History Museum at the Atwater Kent; Craig Bruns, chief curator of the Independence Seaport Museum; Joel T. Fry, curator at the John Bartram Association; and Robert D. and Deepali Schwarz of the Schwarz Gallery. The staff at the Winterthur Museum were also extraordinarily generous with their collection and time, and I am especially appreciative of Leslie B. Grigsby, senior curator, ceramics and glass; Stephanie Delamaire, associate curator of fine arts; Emily Guthrie, library director and NEH Librarian for printed books and periodicals; and Amanda Hinckle, Robert and Elizabeth Owens Curatorial Fellow. In addition, we are fortunate to have found an enthusiastic partner in Ellen Freedman Schultz, associate director of education at the Fairmount Water Works.

The entire staff at PAFA supported *From the Schuylkill to the Hudson* in

numerous ways, and I am deeply grateful to Judith M. Thomas, Mary McGinn, Hoang Tran, Wayne Kleppe, Jennifer Johns, Alexander Till, Barbara Katus, Aaron Billheimer, Mark Knobelsdorf, Michael Gibbons, Sarah Spencer, Jodi Throckmorton, Brittany Webb, Abby King, Monica Zimmerman, Megan McCarthy, Larry Passmore, Erica Land, Alison Campbell-Wise, Michele Besso, and Malini Doddamani. A superb team of interns, volunteers, and work-study students also made meaningful contributions along the way, including Katie Wasserstein, Jess Aquino, and Lily Feinstein. This catalogue is immensely indebted to the keen editorial eye of L. Jane Calverley; the publication development team at Lucia|Marquand; and the talented design of Zach Hooker. Additionally, the groundbreaking scholarship and intellectual support of Wendy Bellion, Alan C. Braddock, Elizabeth Milroy, Laura Igoe, and Therese O'Malley on the topic of the intersection of landscape and art in Philadelphia proved essential to the development and growth of the concept behind the exhibition.

Finally, *From the Schuylkill to the Hudson* would not have happened without Ramey Mize, my intellectual partner in crime, curatorial assistant, and fellow adventurer in Philadelphia waterscapes. Thank you.

ANNA O. MARLEY

This book is published in conjunction with the exhibition *From the Schuylkill to the Hudson: Landscapes of the Early American Republic*, presented at the Pennsylvania Academy of the Fine Arts, Philadelphia
June 28–December 29, 2019

From the Schuylkill to the Hudson: Landscapes of the Early American Republic is made possible by the Henry Luce Foundation. Major support is provided by the Mr. and Mrs. Raymond J. Horowitz Foundation for the Arts, Inc. Leadership support is provided by Julie and James Alexandre, and Bowman Properties, Ltd. Generous support is provided by Brown Brothers Harriman & Co., Louisa C. Duemling, the Newington-Cropsey Foundation, and Dorothy and Ken Woodcock.

Etch and Flow, a companion exhibition in the Richard C. von Hess Foundation Works on Paper Gallery, is supported by 2019–20 Works on Paper Exhibition Season sponsors Linda Seyda and Robert Boris, and by a grant from the IFPDA Foundation.

Historic Exhibitions in 2019–20 are supported by The Templeton Family.

Special Exhibitions in 2019–20 are supported by Jonathan L. Cohen.

The publication of *From the Schuylkill to the Hudson: Landscapes of the Early American Republic* is made possible by a David R. Coffin grant from the Foundation for Landscape Studies and Furthermore: a program of the J. M. Kaplan Fund.

Furthermore:
a program of the J.M. Kaplan Fund

Library of Congress Cataloging-in-Publication Data
Names: Marley, Anna O. Schuylkill River school. | Mize, Ramey. Landscape's expressive eye. | Pennsylvania Academy of the Fine Arts, organizer, host institution.
Title: From the Schuylkill to the Hudson: landscapes of the early American republic.
Description: Philadelphia: Pennsylvania Academy of the Fine Arts, 2019. | "This book is published in conjunction with the exhibition From the Schuylkill to the Hudson: Landscapes of the Early American Republic, presented at the Pennsylvania Academy of the Fine Arts, Philadelphia June 28–December 29, 2019." | Includes bibliographical references.
Identifiers: LCCN 2019012269 | ISBN 9780943836454 (hardcover: alk. paper)
Subjects: LCSH: Landscape painting, American—Pennsylvania—Philadelphia—19th century—Exhibitions. | Landscapes in art—Exhibitions.
Classification: LCC ND1351.5 .F76 2019 | DDC 758/.174811—dc23
LC record available at https://lccn.loc.gov /2019012269

Published by Pennsylvania Academy of the Fine Arts, Philadelphia
www.pafa.org

PAFA
Pennsylvania Academy
of the Fine Arts

Available through
ARTBOOK|D.A.P.
75 Broad Street, Suite 630
New York, NY 10004
www.artbook.com

Produced by Lucia|Marquand, Seattle
www.luciamarquand.com

Edited by L. Jane Calverley and Judith M. Thomas
Designed by Zach Hooker
Typeset in Walbaum by Maggie Lee
Proofread by Carrie Wicks
PAFA production managed by Judith M. Thomas
Color management by iocolor, Seattle
Printed and bound in China by Artron Art Group

Cover front and page 4: plate 13, p. 43; cover back and pages 2–3: plate 22, p. 52; pages 8–9: plate 41, p. 71; pages 20–21: plate 34, p. 65; pages 28–29: plate 40, p. 70; page 40: plate 11, p. 41; page 62: plate 32, p. 63; foldouts: plates 44 and 45, p. 73.

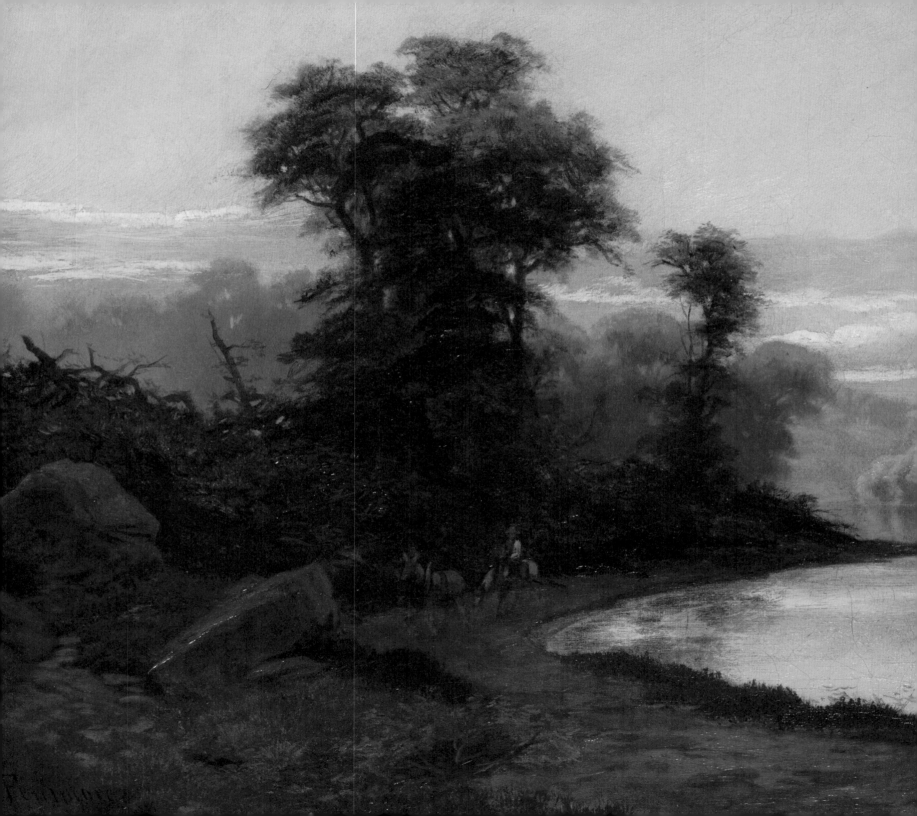